COWPARADE KANSAS CITY

COWPARADE
KANSAS CITY

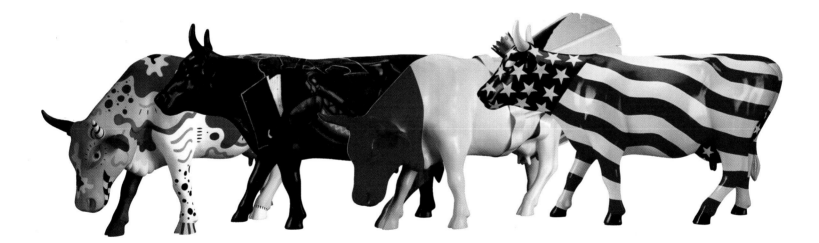

PHOTOGRAPHY BY RON BERG, ALEX BOURDO, JOHN DESALVO, ANTHONY LOEW, CHRIS STANLEY, AND MICHAEL TEKLER

WORKMAN PUBLISHING • NEW YORK

cow♣parade™

Copyright © 2001 by CowParade Holdings Corporation

Text written by Tom Craughwell

Interior photography by Ron Berg and Alex Bourdo, Ron Berg Photography, Kansas City, Missouri, and Anthony Loew, New York.

Cow silhouettes by John DeSalvo, Chris Stanley, and Michael Tekler, CowParade Graphics.

Cover cow photographs by Anthony Loew.

Cows on title page (l. to r.): *CowDoodle, 18th and Bovine, Shuttle Cow, American Royal.*

Historical photographs and postcards on pages 4–8 courtesy Special Collections, Kansas City Public Library, Kansas City, Missouri.

Library of Congress Cataloging-in Publication Data is available.

ISBN 0-7611-2540-X

Workman books are available at special discounts when purchased in bulk for premiums and sales promotions as well as for fund-raising or educational use. Special editions or book excerpts can also be created to specification. For details, contact the Special Sales Director at the address below.

Workman Publishing Company, Inc.

708 Broadway

New York, NY 10003-9555

www.workman.com

Printed in the United States of America

First printing July 2001

10 9 8 7 6 5 4 3 2

CONTENTS

At the Moolin Rouge

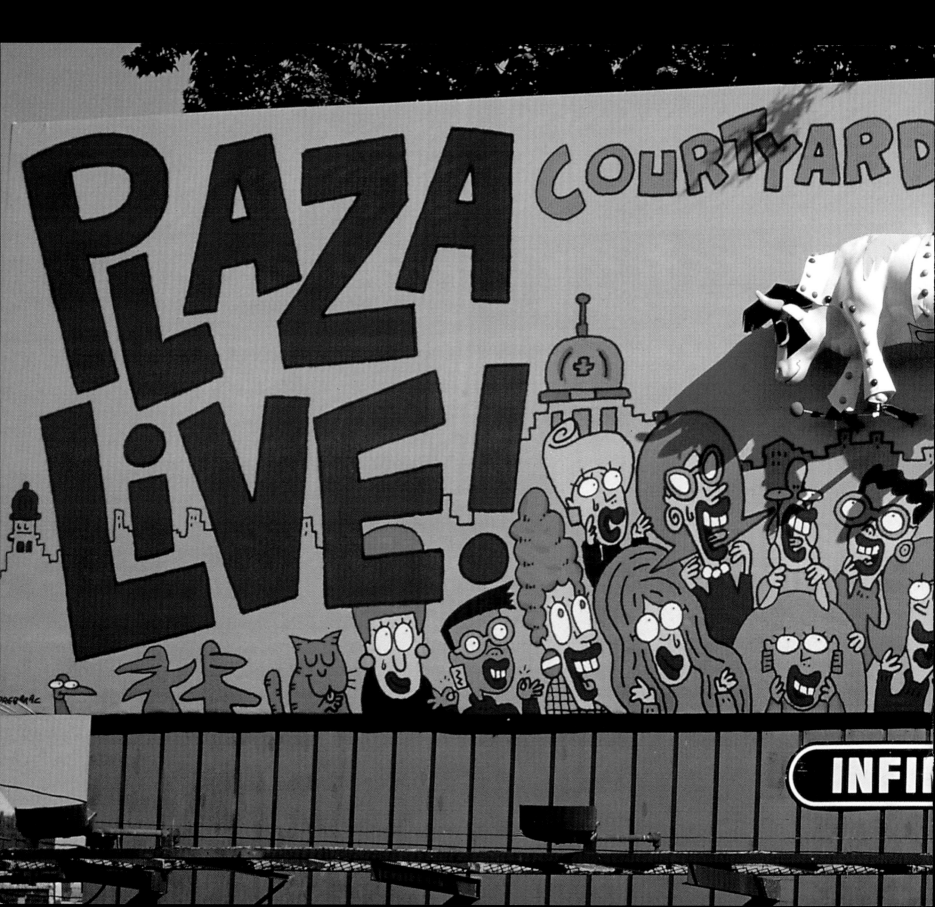

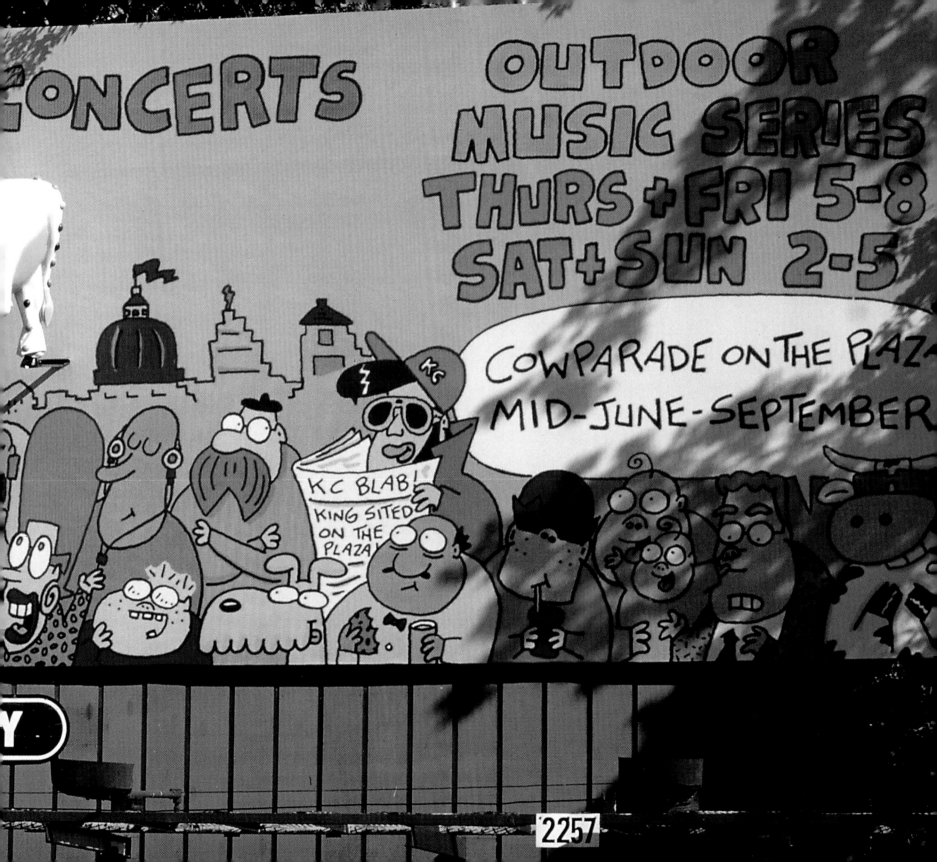

FOREWORD BY MAYOR KAY BARNES

Greetings! The cows have come home! This book presents CowParade Kansas City, certainly a different parade from the herds of cows that once walked our streets and stockyards. The charming cows are "cattle canvases" and have been for this city not simply sources of whimsy and delight, but an opportunity for artists and lovers of art to create and enjoy these imaginative works.

CowParade Kansas City, our "ruminants on review," has served to amuse and enchant us. The cows have brought people together to talk and laugh in admiration and awe; they have offered wonderful entertainment for residents and the many tourists who have come to see them, as well as opportunities to make seemingly endless puns. But perhaps the best element

Kay Barnes,
Mayor of Kansas City, Missouri

of CowParade is that these cows will be rounded up and sold at auction for the benefit of children's education programs.

The first documented cattle drive to Missouri was in 1846, and for many years, despite the importance of cattle to our city, people interpreted the sobriquet "Cow Town" as an insult, a term to not just avoid, but disprove. The cows on Kansas City streets in the summer of 2001 have provided a new, droll definition of Cow Town, and we are delighted. I hope you are, too.

Sincerely,

Kay Barnes

1

INTRODUCTION

BY JERRY ELBAUM, PRESIDENT OF COWPARADE

Welcome to CowParade Kansas City 2001.
What you will see on the following pages are the spectacular creations of hundreds of artists who participated in this memorable event. Some of these are the works of preeminent artists; others the labors of aspiring student artists. Altogether, more than 200 original works of art were created for exhibition in a variety of public and private venues. CowParade Kansas City 2001 marks the first time a public art event of this magnitude has been staged in Kansas City.

One of the most rewarding and interesting elements of the event is a program that involved the Kansas City public schoolchildren. The *Kansas City Star,* the Star in Education, and the CowParade Foundation, Inc., sponsored an art contest for schoolchildren. Winners were chosen for elementary, middle/junior high, and senior high school levels.

A jazz combo gets the party started

The schools submitting winning designs each decorated a cow for display in CowParade Kansas City 2001. One of the primary objectives of CowParade is to foster art and art programs in the schools, as we strongly believe that art helps schoolchildren better understand and relate to their environments, encourages the development of creative skills, and builds self-confidence.

American Royal

2

Jerry Elbaum

Why the cow? It is simply a unique, three-dimensional canvas to which the artist can easily relate. There is really no other animal that can adequately substitute for the cow and produce the level of artistic accomplishment evident in this book. The surface area and bone structures are just right, as well as the height and length. Even more important, the cow is an animal we all love. One of the first words most of us say in our infancy is "moo." Cows provide the milk that fosters our development, and milk is the basis of beloved childhood treats like ice cream. The cow is whimsical, quirky, and never threatening. That is why so much of the art in this show causes us to laugh, smile, and just feel good.

I thank all the artists who participated in this undertaking and the many corporate, business, and individual patrons whose sponsorships helped underwrite the cost of the exhibit. Nothing would have been possible without the leadership of

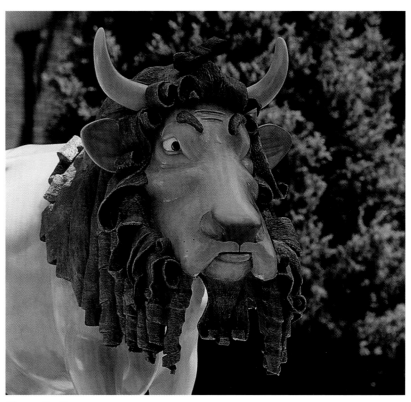

Cowardly Cow

Karen Holland and Dana Nelson, together with the many other volunteers who assisted them, and the support of the great city of Kansas City, particularly Mayor Kay Barnes and the Parks and Recreation Department.

Jerry Elbaum

Jerry Elbaum

President, CowParade

HISTORY ON THE HOOF

[THE STORY OF CATTLE IN KANSAS CITY]

Kansas City is celebrated for its jazz clubs, of course, and for its fountains. There's the shopping at Country Club Plaza, the revitalized residential districts around Downtown, the majesty of Union Station, the jazz and Negro Leagues museums at 18th and Vine. And the barbecue just about everywhere. But this fun, sophisticated city has not forgotten its roots as the original cow town. No wonder the cattle of CowParade wanted to spend the summer here.

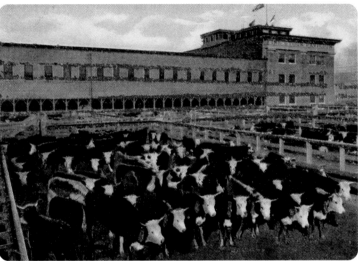

An early postcard depicting the old Kansas City Stockyards

The first cattle came here from Texas in the 1850s, driven north in massive herds by early American cowboys. And it wasn't by chance that the drovers took their cows to Kansas City. With its proximity to St. Louis, Chicago, and the cities of the East, Kansas City was ideally situated for the cattle business. While cattlemen from the West and buyers from the East dickered over the price per head, the longhorns fattened up on the tall grass ranges

The Bovine Timeline

c. 4000 B.C.
The first cheese is made in Switzerland.

c. 2000 B.C.
When three angels appear at Abraham's tent, he serves them butter, milk, and a fatted calf.

c. A.D. 100
An anonymous poet creates *The Tain*, Ireland's national epic about a war that started over a cattle raid.

960
Monks from Brittany introduce the first dairy cows to the island of Guernsey.

1493
The first cattle in the New World come ashore with Christopher Columbus on the island of Hispaniola.

c. 5000 B.C.
Farmers in Greece, Turkey, and Crete start domesticating wild cattle.

c. 3000 B.C.
Queen Hete-Phere of Egypt accepts the honorary title "Guardian of the Corporation of Butchers."

c. 500 B.C.
Darius, a Persian gourmand, gives the first banquet in which the main course is a roasted whole ox.

c. 850
Vikings bring the ancestors of British White cattle to England.

1029
The Norse king Sitric hands over 1,200 cows to ransom his son, Olaf.

1521
The first longhorn cattle arrive in Mexico with Cortés.

1540
Coronado brings the first cattle into what will later become the United States.

west of the city. By 1857, Kansas City was the premier cow town on the western frontier, with some 52,000 longhorns sold in its cattle market that year.

The city's cattle business virtually dried up during the Civil War. Union blockades made it impossible for Texas ranchers to get their cattle to market. With no outlet for their animals, the cattlemen let their longhorns run wild. It has been estimated that by the time the war ended in 1865, there were 5 million head of undomesticated cattle on the Texas prairies.

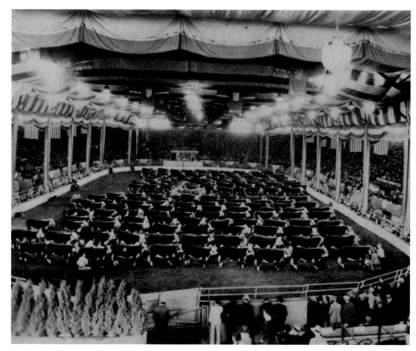

A Kansas City cattle show

Cattle roamed the pastures surrounding the city by the thousand

It was the Confederate veterans of Texas who rebuilt the cattle industry. Four years of war had almost exhausted the supply of cattle in the East.

The big urban markets were hungry for beef, and Texas had lots of it. In 1866, the former Confederates rounded up the first herds of wild longhorns and drove them north back to Kansas City, where cattle were fetching an unprecedented $40 to $50 a head.

1611
The first cows in English North America arrive at Jamestown.

1624
Devon cattle arrive at Plymouth Colony.

1636
The first meatpacking plant is established in Springfield, Massachusetts.

1783
Shorthorn cattle, which can provide milk, meat, and labor, arrive in Virginia.

1817
Ohio livestock farmers begin grain-feeding their cattle and then driving them to market in New York.

1846
The first cattle drive on record travels from Texas to Missouri.

1857
Kansas City is the premier cow town on the western frontier, with some 52,000 longhorns sold in the city's cattle market.

1860
A census shows that there are 31 million people in the United States and 26 million cattle in Texas.

1866
The first post–Civil War cattle drives come up to Missouri from Texas.

1868
Two slaughterhouses open in Kansas City, and the town's meatpacking boom begins.

1869
The Hannibal Bridge is completed, giving cattlemen a direct rail link from Kansas City to all points east.

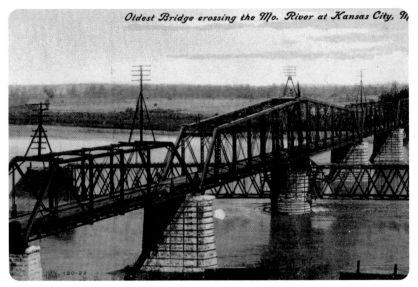
The Hannibal Bridge

Once again, business boomed in Kansas City, and it had cows to thank. In 1869, the savvy town fathers completed the Hannibal Bridge, the first bridge across the Missouri River. It stretched 1,371 feet, and opened for business on July 3 of that year. The idea was to make Kansas City the number-one market on the Missouri, with a direct rail link to Chicago and other points east. And it worked. By 1871, seven railroads ran through Kansas City, the stockyards opened in West Bottoms, there were four meatpacking plants, and the city built the Livestock Exchange, the world's largest building devoted exclusively to the cattle trade. Kansas City was in the middle of a beef bonanza; in one year its banks handled $3 million in cattle money. And when refrigerated train cars were invented in the early 1870s, Kansas City's cattle and meat business grew even bigger.

For most of the 19th century, when a rancher talked about his cattle, he meant Texas longhorns. By 1880, however, the longhorns were getting competition from European varieties—

A cattle exposition

1872
Reflecting the money to be made in cattle, the Kansas City Livestock Exchange Building is doubled in size.

1878
Stockyards expand—they are to be found now on both the Kansas and Missouri sides of the Missouri River.

1880
Cattle ranches in the American West extend from the Rio Grande to the Canadian border.

1883
Cattlemen hold Kansas City's first Fat Stock Show to promote new varieties of beef cattle.

1884
Dr. Harvey Thatcher of Potsdam, New York, invents the milk bottle.

1886–87
A blizzard of biblical proportions all but destroys Kansas's cattle industry.

1899
A tent on Genessee Street hosts the National Hereford Cattle Show, which continues today as the American Royal Livestock Show.

1904
The hamburger is introduced to a hungry public at the St. Louis World's Fair.

c. 1910
African-American entrepreneur Henry Perry opens his barbecue stand.

1911
The automatic rotary milk bottle filler and capper is perfected.

1917
Fire in Kansas City's West Bottoms stockyards destroys 17,000 cattle and hogs. Damage is estimated at $1.7 million.

1919
Torrington, Connecticut, becomes the first town in America to sell homogenized milk.

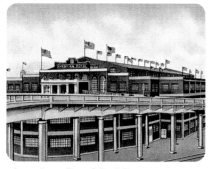
American Royal Building

purebred Angus, shorthorn, Galloway, and Hereford cattle. To showcase their pedigreed stock, breeders mounted Kansas City's first cattle show in 1882. It was called the Kansas City Fat Stock Show and was held in River View Park. In 1899, the show was given a more regal name, the American Royal Livestock Show.

Although Missouri is still the second-largest producer of beef in the United States (Texas is number one), Kansas City is no longer the cattle mecca it once was. The stockyards of West Bottoms are gone. The American Hereford Association Building is still standing—but without the

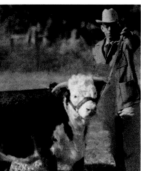
A champion Hereford and proud breeder

Hereford that once stood atop its nearby pedestal. The building's offices are now used by corporations that have nothing to do with cattle. The American Royal Livestock Show remains an annual event, but it has been expanded to include a horse show and a rodeo. Nonetheless, Kansas City remains a great place to get a steak, not to mention the city's legendary barbecue.

Now a new breed of cows is on the trail to Kansas City. A herd of more than 200 fiberglass bovines has hit the streets

1929
Walt Disney's Clarabelle Cow makes her debut in the animated cartoon *The Plow Boy.*

1933
Four Guernsey cows make the trip to Antarctica with Admiral Richard Byrd.

1938
Bulk tanks begin to replace the old milk cans.

1943
October 19 is the busiest day in the history of the Kansas City stockyards, when some 64,000 head of cattle are processed.

1948
The first plastic-coated paper milk cartons are introduced.

1954
The landmark Hereford statue is mounted atop a 90-foot plinth on the American Hereford Association Building.

1961
A British Friesian cow gives birth to the heaviest live calf ever. The newborn tips the scales at 225 pounds.

1991
On September 26, Kansas City stockyards hold their last auction.

1993
Big Bertha, a Dremon cow, dies at age 48 years and nine months. She was the oldest cow on record.

1996
Missouri ranks second only to Texas in the number of cattle: 6.5 million in Missouri, compared to 15 million in Texas.

2001
The Hereford statue is removed from the former American Hereford Association Building, to be reerected in a Kansas City park.

CowParade arrives in Kansas City.

this summer—painted, appliquéd, and otherwise embellished by artists from far and near and looking flashier than Glen Campbell's rhinestone cowboy. They are part of CowParade, the international outdoor art sensation that began in Zurich, Switzerland, then *moo*-ved on to Chicago and New York City.

You'll find these cows in herds grazing in the parks, moseying through the plazas, and stampeding down the concrete canyons of Kansas City. They're a tribute to the city's frontier heritage, a celebration of the genius of our contemporary artists—and they're great fun to look at.

So pull on your cowboy boots, grab your Stetson, and head out to inspect the herd.

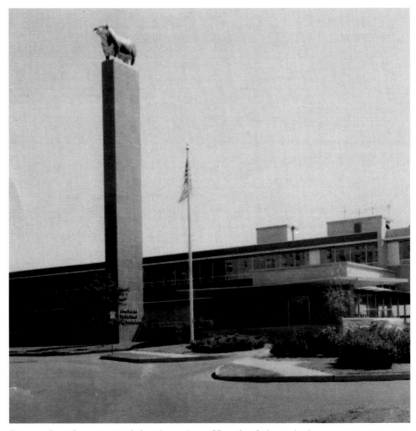

Former headquarters of the American Hereford Association

Panoramic view of the West Bottoms

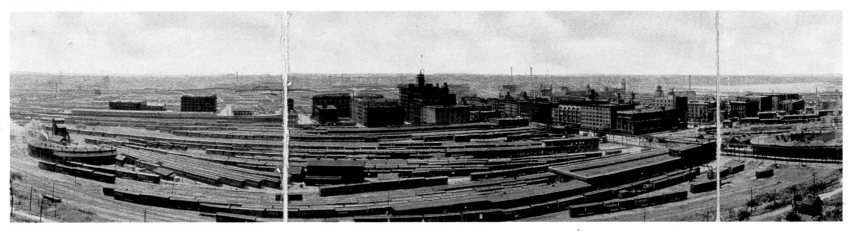

A COW IS BORN

Tom Edmondson has always been intrigued by computer circuit boards and wanted to design a cow that showcased their various diodes, switches, transistors, chips, and relay and circuit trails. *Cowputer 2001*—a working computer with Internet access in a bovine belly—is the perfect combination of work and play for Tom. And it certainly confirms that "everything is up-to-date in Kansas City." Worldspan, where Tom works in interactive technologies, sponsored the project.

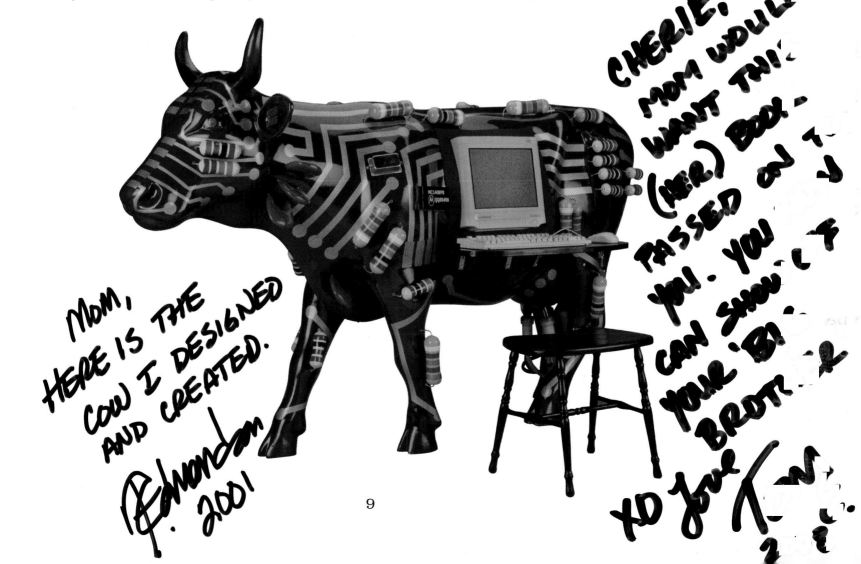

Mom, HERE IS THE COW I DESIGNED AND CREATED. Edmondson 2001

CHERIE, MOM WOULD WANT THIS (HER) BOOK. PASSED ON TO YOU. YOU CAN SHOW YOUR BROTHER. XO love Tom 2008

9

1. The white fiberglass cow arrived at Worldspan's maintenance room for Tom to start painting.

2. Tom took careful aim as he sprayed the cow with three coats of green enamel paint.

3. Tom masked with tape the parts of the cow's body that will remain green.

4. Tom then spray-painted the exposed areas with silver. He applied three layers of silver paint so that blind or visually impaired visitors will be able to feel the raised design of the "circuits."

5. Tom used a jigsaw to cut a hole in the side of the cow for the computer's monitor. Tom cut another hole in the cow's flank that will house the computer's central processing unit.

6. Tom made computer chips from wood and sheet metal and silk-screened the model numbers on the top. He constructed the crystals from small cake pans whose bottoms he painted with text. He made the resistors and capacitors from plaster of paris, which he had poured into custom-made silicone molds.

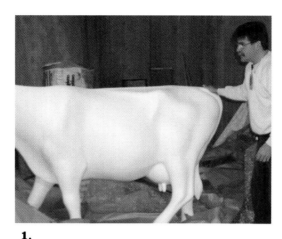
1.

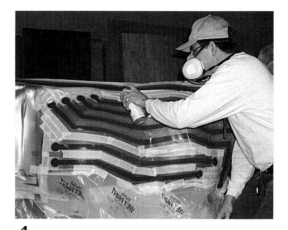
4.

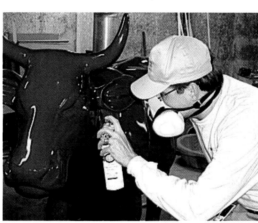
2.

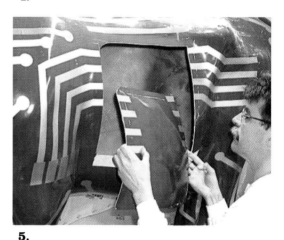
5.

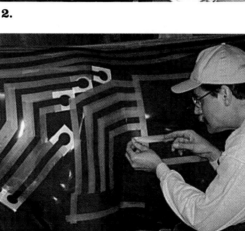
3.

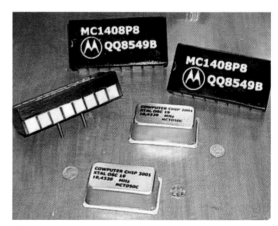
6.

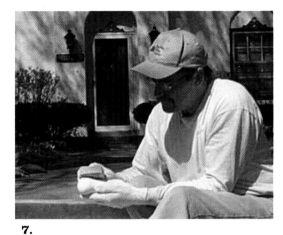

7.

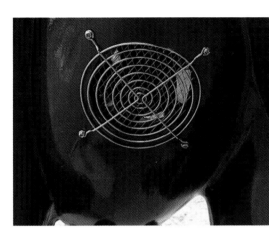

10.

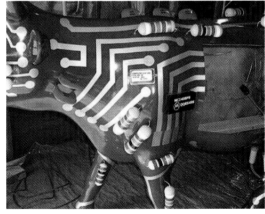

8.

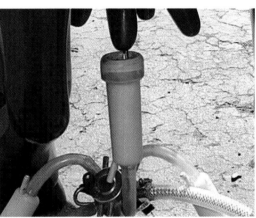

11.

9.

12.

7. Tom sanded the resistors and capacitors.

8. He then painted them.

9. He then attached them to the body of the cow with wires.

10. Tom installed a four-inch fan in the back of the cow to bring cool air into her body and exhaust the hot air out two vents located in her hips. This was done to prevent the computer from overheating.

11. The electrical power cord is wired through a milking cup that is attached to the cow's teats and up into her belly, where it is attached to a surge protector.

12. Finally, after 400 hours of work, Tom installed the computer inside the cow. He then flipped the power switch and let his neighbor Noah Richmond type the first entry into the "Cow-Journal." The cow's birth was celebrated with a party of Tom's neighbors, who toasted its arrival with champagne glasses brimming with milk.

Country Club Plaza

In 1906, real estate developer J. C. Nichols was building fine houses in the Country Club district of Kansas City. Unfortunately, the road to the new development led through a swamp, past a pig farm and garbage dump. Nichols believed these eyesores were hurting sales, so in 1907 he started acquiring the land. He drained the swamp, carted away the garbage, got the pig farmer to relocate, and started building a posh shopping district—the first in the United States designed specifically with the automobile in mind.

The first retail building in what Nichols called Country Club Plaza—better known today simply as the Plaza—welcomed shoppers in 1923. As more and more stores opened, Nichols embellished his Plaza with fountains and sculptures imported from Europe. Today, the Plaza is home to more than 150 shops, including department stores, financial institutions, restaurants, hotels, and theaters, making it one of the world's most attractive shopping and entertainment districts.

Cowdolier
Artist: Mark Cordes
Patron: The Country Club Plaza

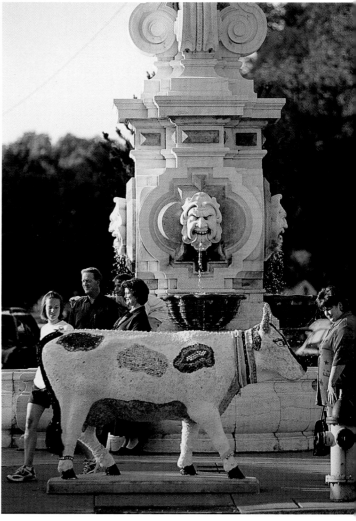

Plaza Cow
Artist: Carol Hensley
Patron: The Country Club Plaza

Prairie Jewel
Artist: Carol Rose
Patron: DeBruce Grain, Inc. / Flagship Travel, LLC / Interconnect Devices / Rob Reintjes, Jr. / The Uhlmann Co.

Cowlvador Dali

Artist: Paseo Academy of Visual and Performing Arts
Patron: The Country Club Plaza

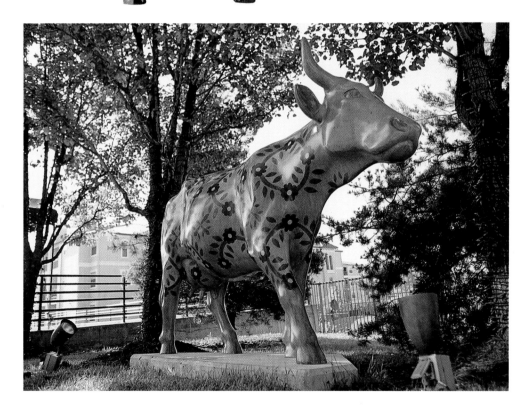

Quilted Wooden Cow

Artist: Mary Beth Whalen
Patron: Grand Street Café

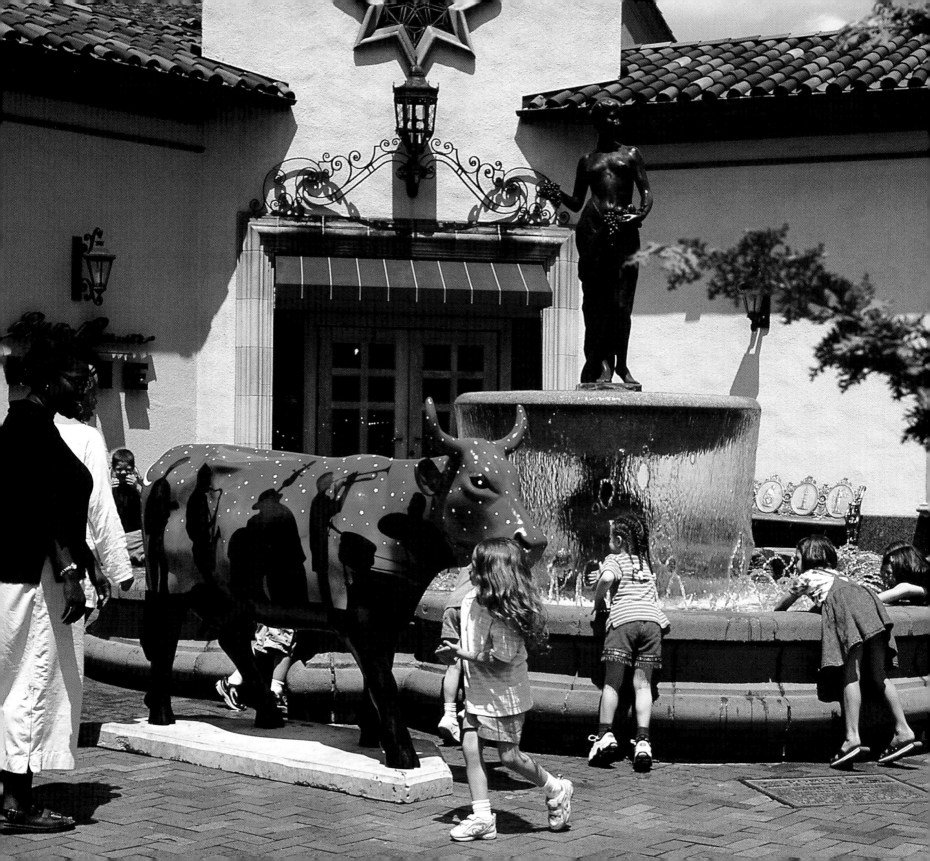

High Steaks Poker
Artist: John Lewis
Patron: Clarkson Construction Company

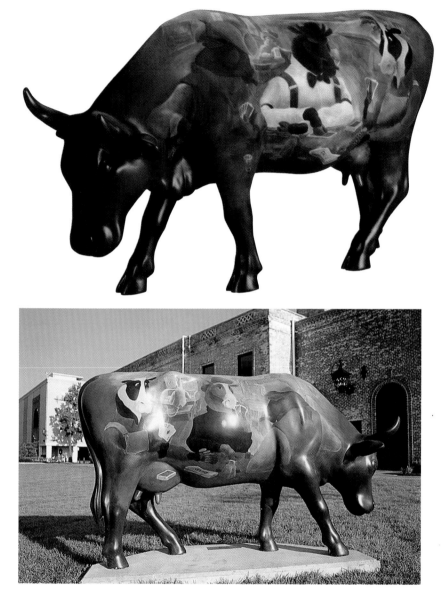

Jazzy Cow
Artist: Asher B. Johnson
Patron: The Country Club Plaza

Carousel Cow
Artist: Marla Storey
Patron: Sun Fresh

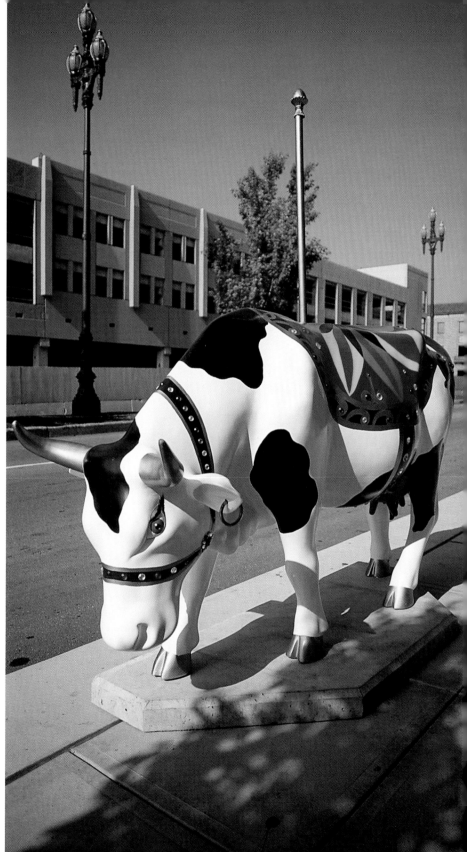

Hide, Hide, the Cow's Inside
Artist: Judy K. Tuckness
Patron: Castle Mountain Ranch

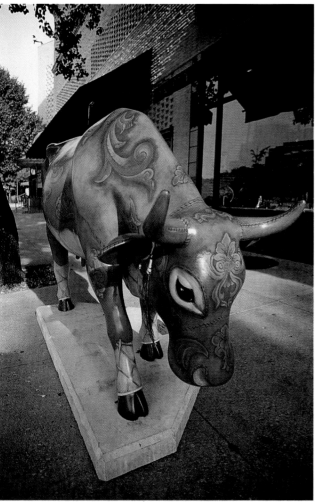

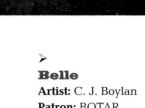

Belle
Artist: C. J. Boylan
Patron: BOTAR
Organization

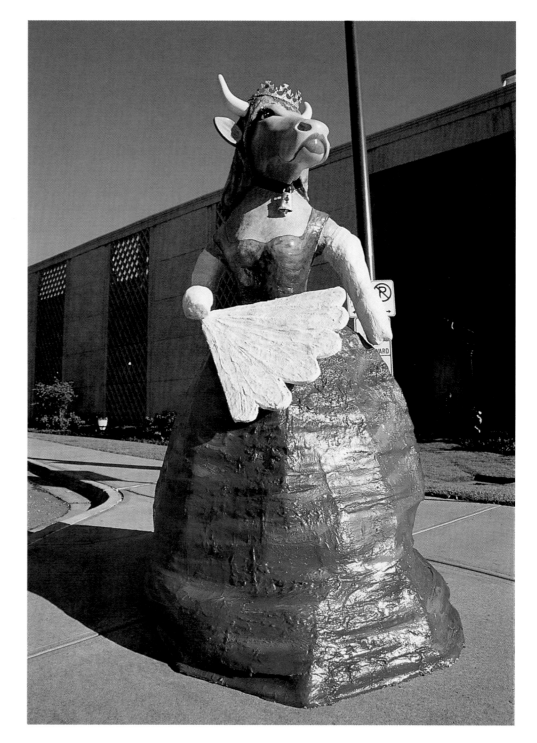

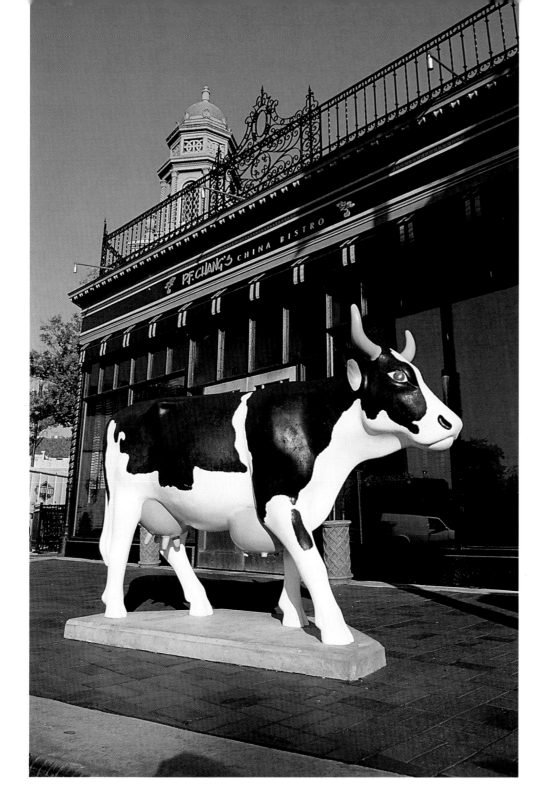

Udder Confusion
Artist: Al Page—Lynn Manos Huber Studio
Patron: KMBC-TV 9

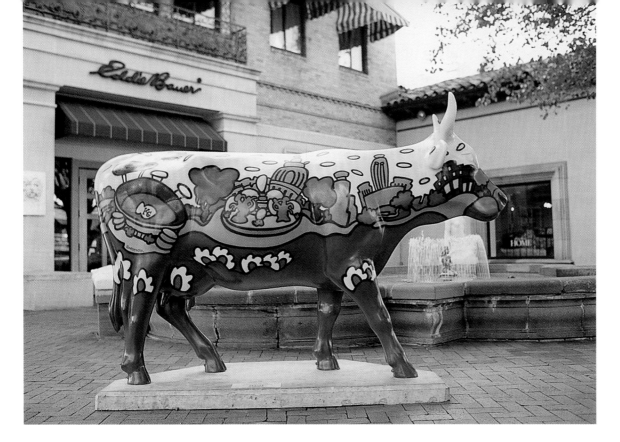

The Art of Americow
Artist: Eclectics: An Artists' Cooperative
Patron: The Country Club Plaza

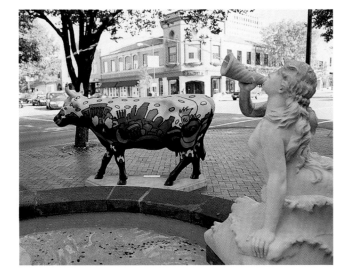

K.C. Road Trip Cow
Artist: Edward J. Bartoszek
Patron: The Country Club Plaza

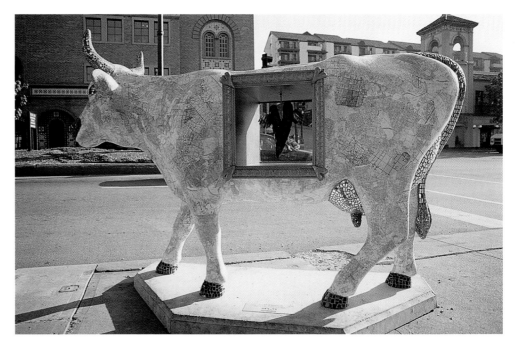

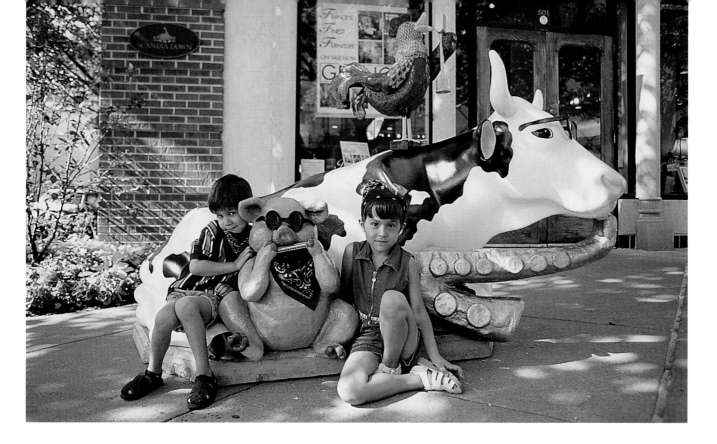

Mixed Plate Blues
Artists: 4 Friends—Maribel, Veronica, Jackie, Jonna
Patron: The Country Club Plaza

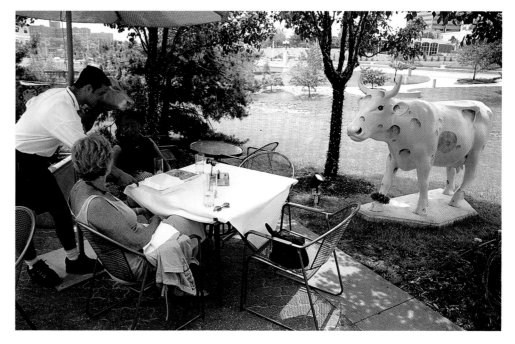

Miss Swiss
Artist: Marilyn York
Patron: Grand Street Café

Beadazzled Bovine
Artist: Janna Bullock McConnell
Patron: Helzberg Diamonds

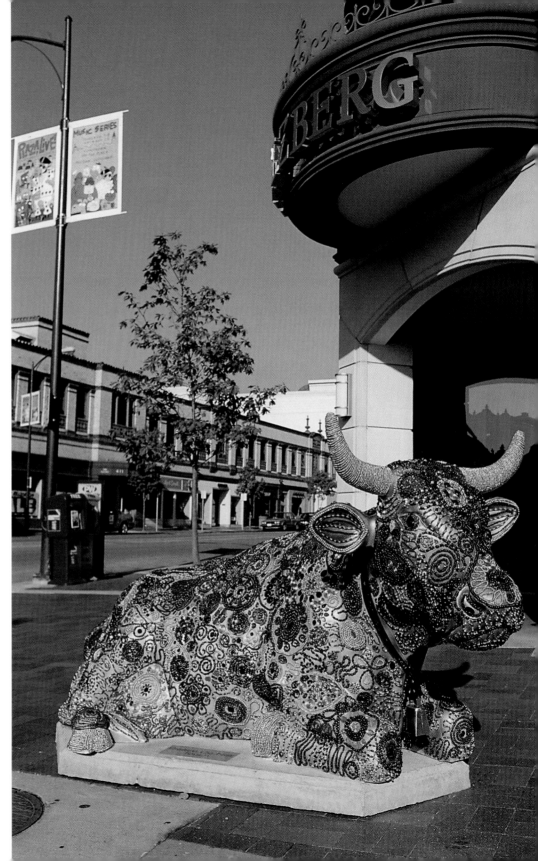

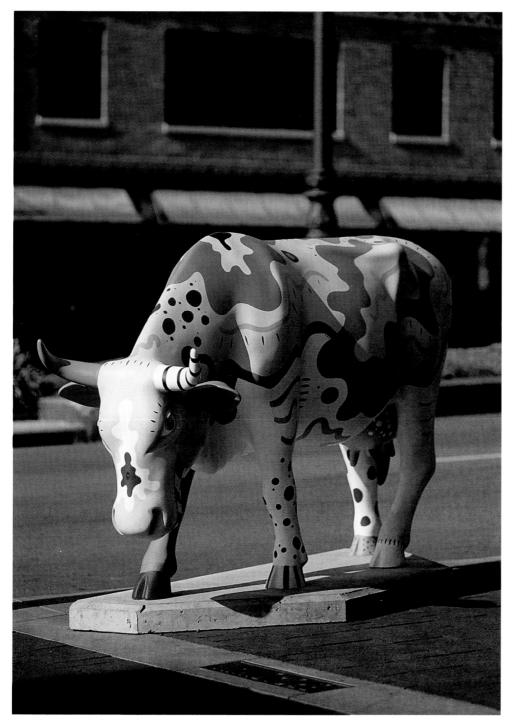

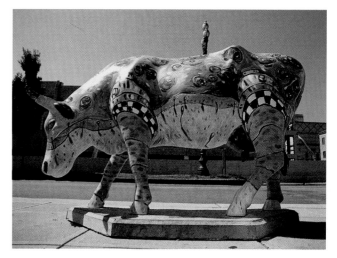

Shaken Not Steered
Artist: Mike Savage
Patron: Kansas City Parks and Recreation

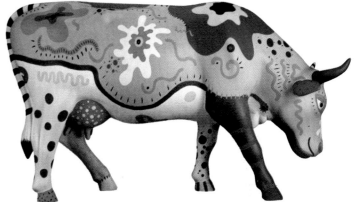

CowDoodle
Artist: Ann Clemens
Patron: Sonnenschein Nath & Rosenthal

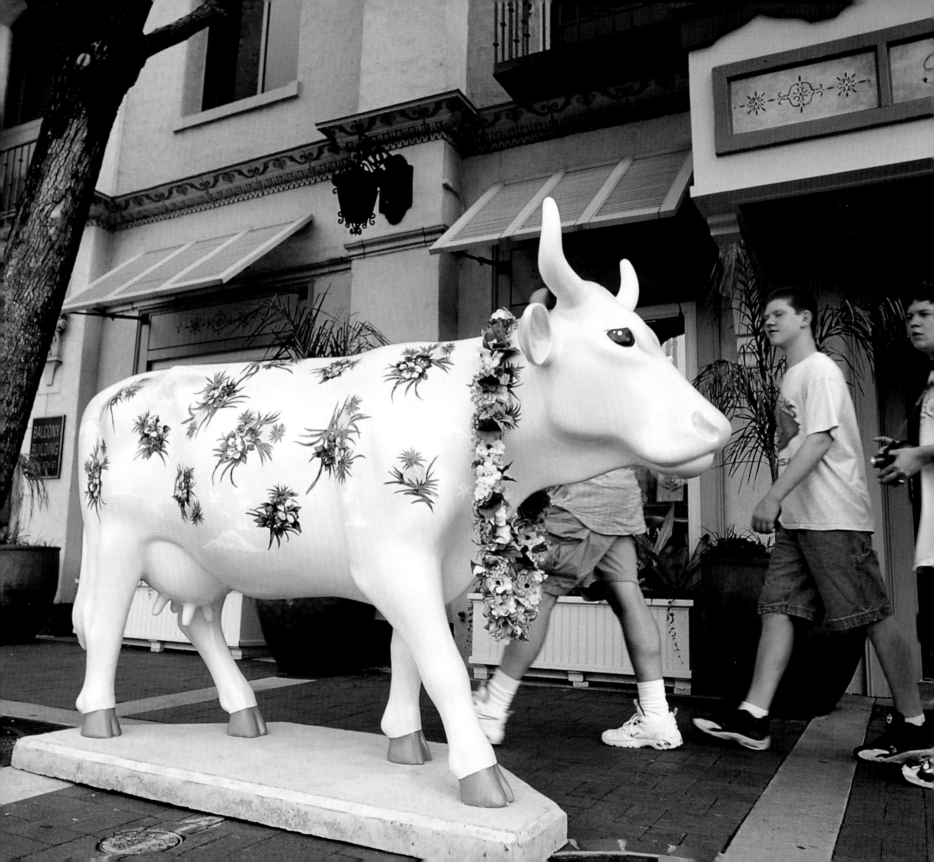

Bahamian Bovine

Artist: Viewpoint International, painted by Ben and Karen
Patron: Tommy Bahama's Tropical Emporium

Super Cow

Artist: Susan Van Well
Patron: The Sosland Family Foundation

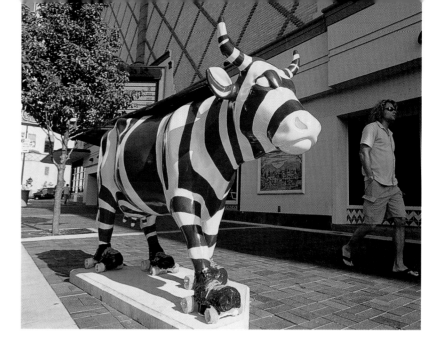

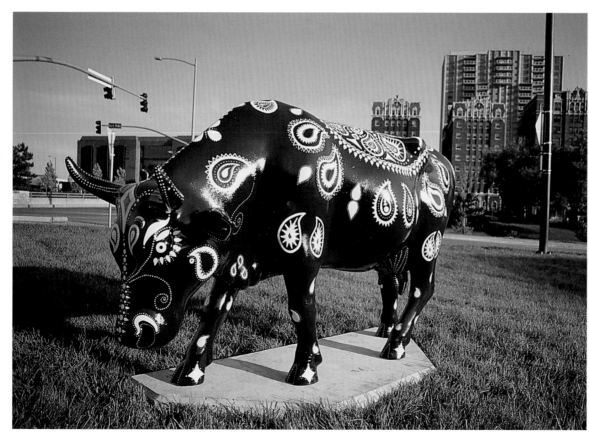

Bandanna Cow

Artist: Cynthia Emery Chilen
Patron: Belger Cartage Service Inc.

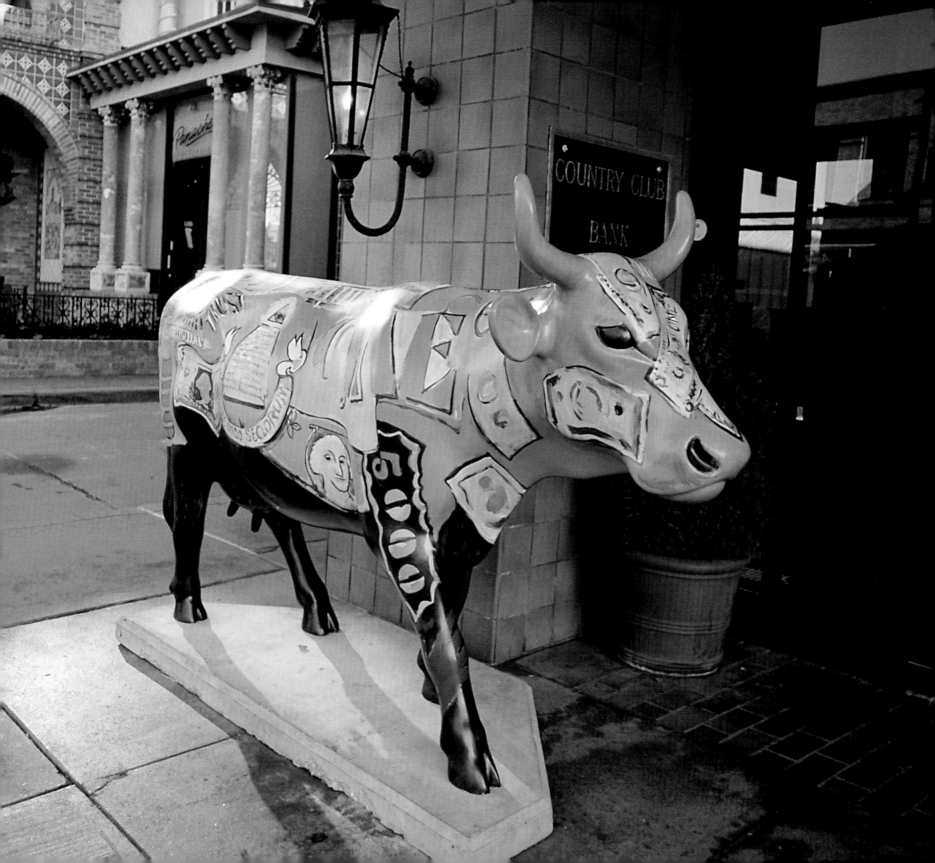

Cow Barn
Artist: Mary Beth Whalen
Patron: Grand Street Café

◄

Cash Cow
Artist: Marie Mason
Patron: Country Club Bank

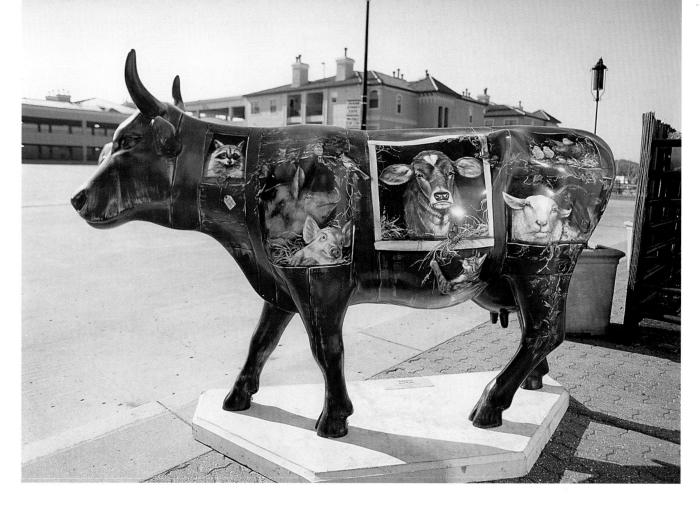

Legend-Dairy Baseball
Artist: Ron Raymer
Patron: Grand Street Café

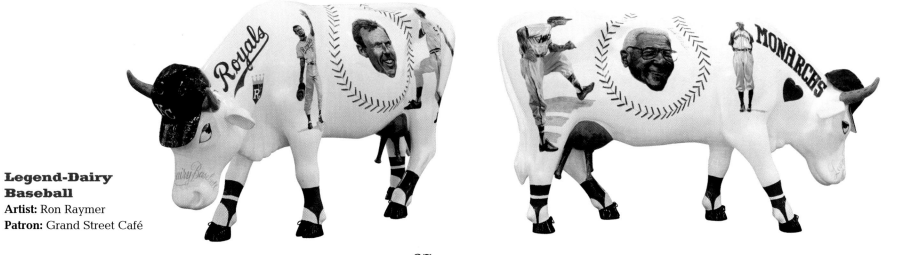

Cow Grazing in the Flint Hills
Artist: Susan McCarthy
Patron: Kansas City Life
Insurance Company

➢ ➢
Bow Vine
Artist: Mindy Scudder
Patron: H & R Block

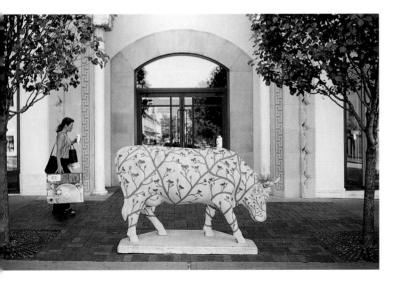

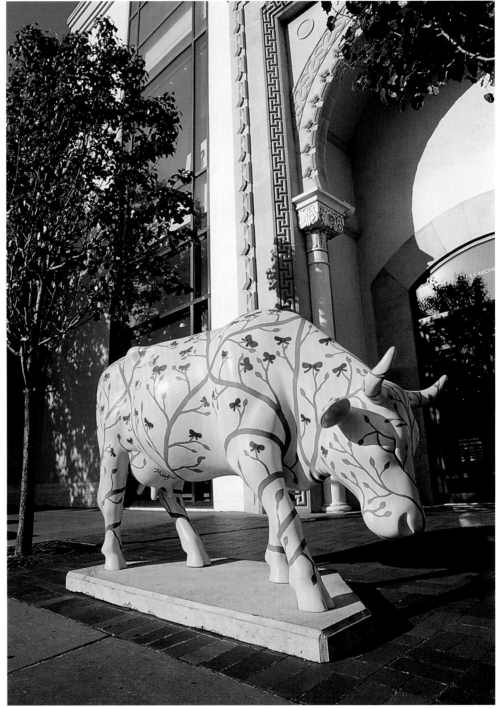

28

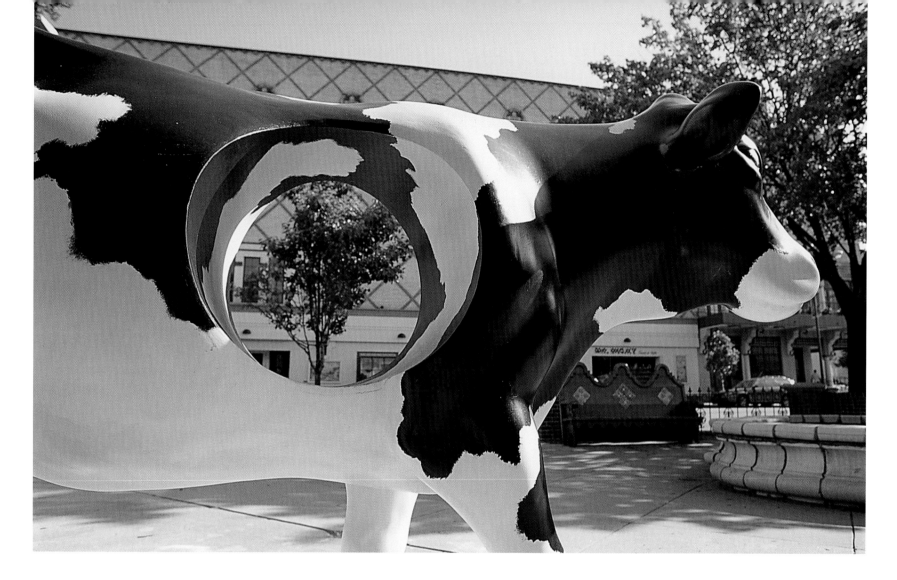

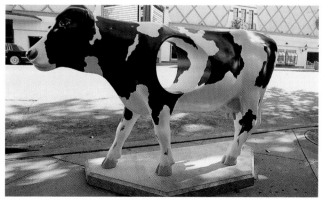

Hole-stein
Artist: Judy K. Tuckness
Patron: Bayer Corporation

Dreamoooer
"Be Still and Know"

Artists: Jewles Greenstreet Klinghoffer assisted by Diane Wilkerson

Patron: Hen House Markets

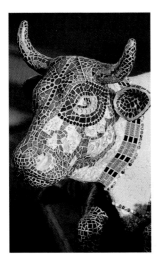

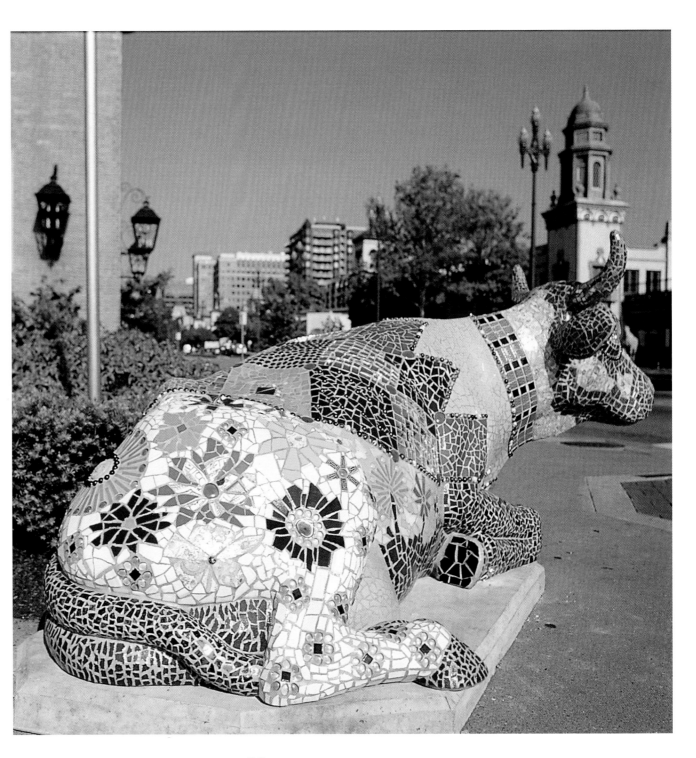

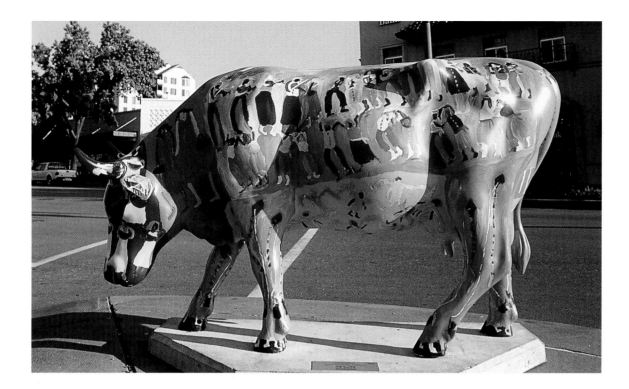

Summertime
Artist: Woodie Long
Patron: The Country Club Plaza

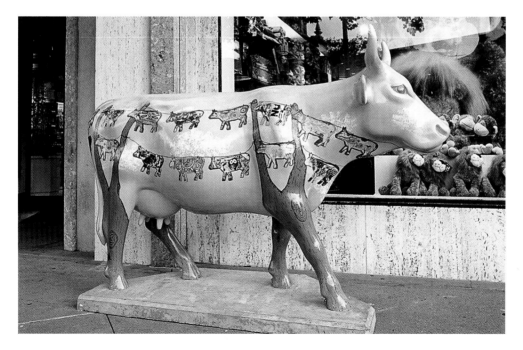

Cowsline
Artists: Linda McMorris
Iliff and Prairie Star
Middle School 7th
Grade Students
Patron: The Country
Club Plaza

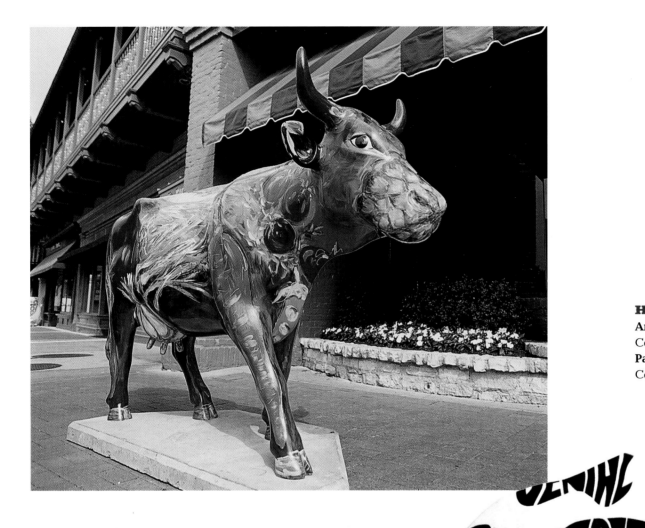

Veggie Burger
Artist: Cynthia Hudson
Patron: Houston's Restaurants
& Fairway Grill

HEP Coward
Artist: Sudler & Hennessey
Communications
Patron: Sudler & Hennessey
Communications

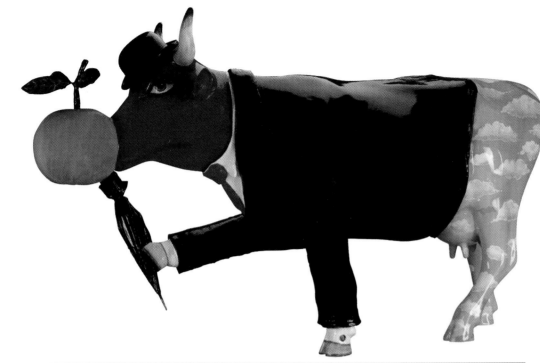

MOOgritte
Artist: Stan Chrzanowski
Patron: The Fairmont Hotel

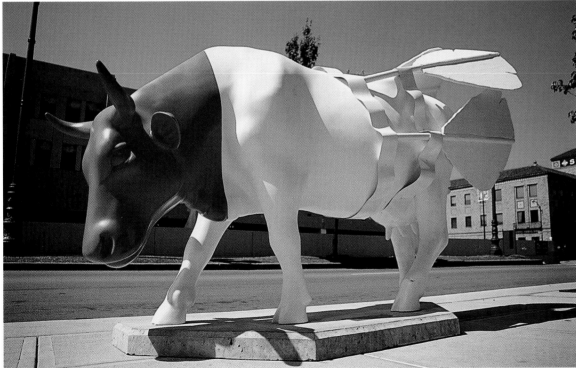

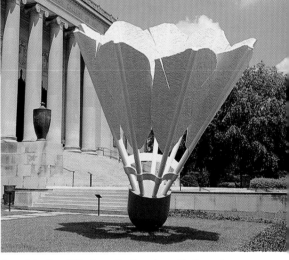

One of the four Oldenberg shuttlecocks on the lawn of the Nelson-Atkins Museum of Art.

Shuttle Cow
Artists: Sam Wagner
and Kip Brown
Patron: KansasCity.com

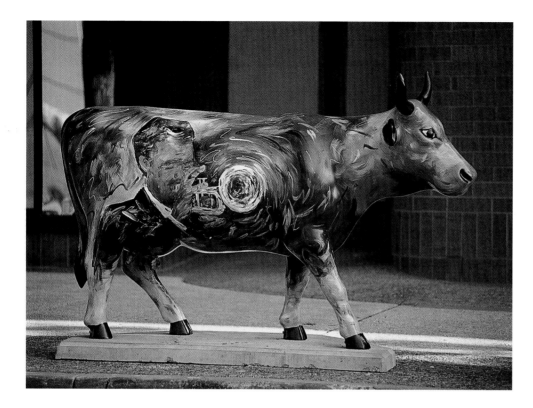

Going to Kansas City
Artist: Cynthia Hudson
Patron: The *Kansas City Star*

Tululip
Artist: Jane Booth
Patron: The Country Club Plaza

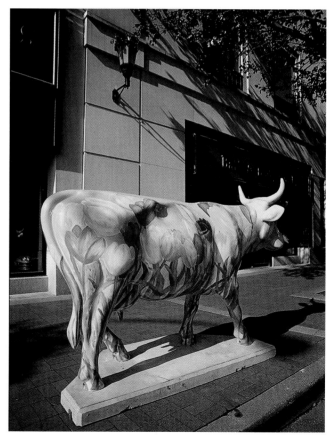

Brown Dotted Swiss
Artist: Marilyn York
Patron: The Country Club Plaza

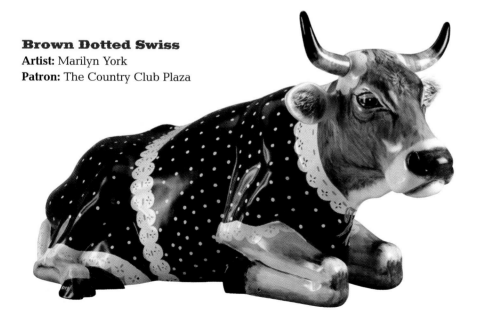

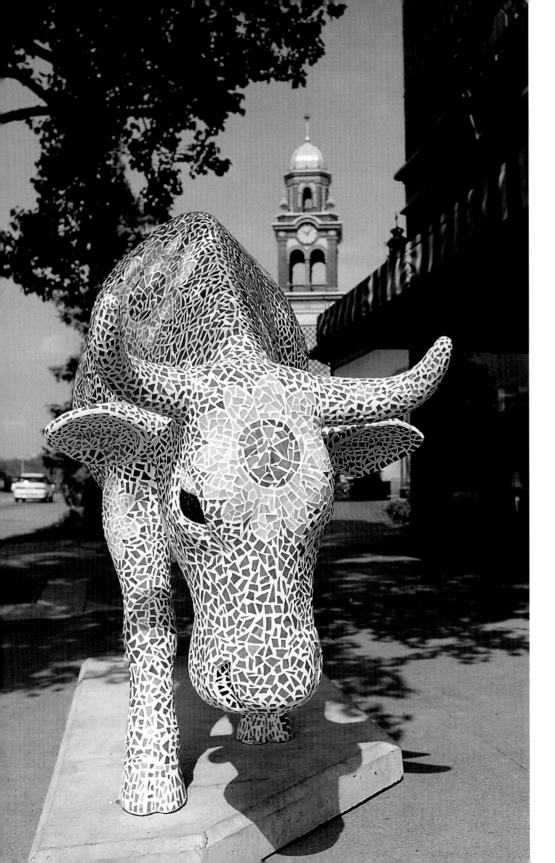

Van Cow
Artist: Lindsey Ross at Blue Valley North High School
Patron: The Country Club Plaza

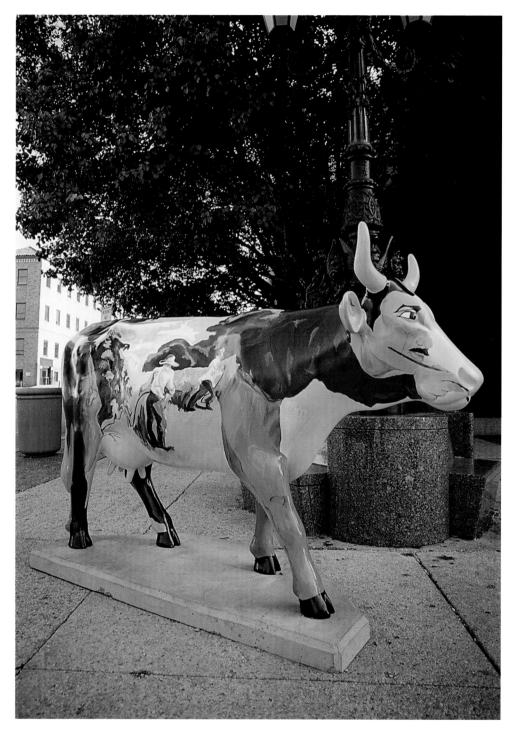

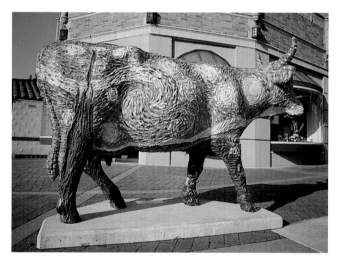

Homage to Thomoos Hart Benton
Artist: Anita Toby
Patron: The Country Club Plaza

Starry Starry Cow
Artist: Wink
Patron: The Country Club Plaza

36

June ann reta
Artist: Stacy Hoyt for Kate Spade
Patron: The Country Club Plaza

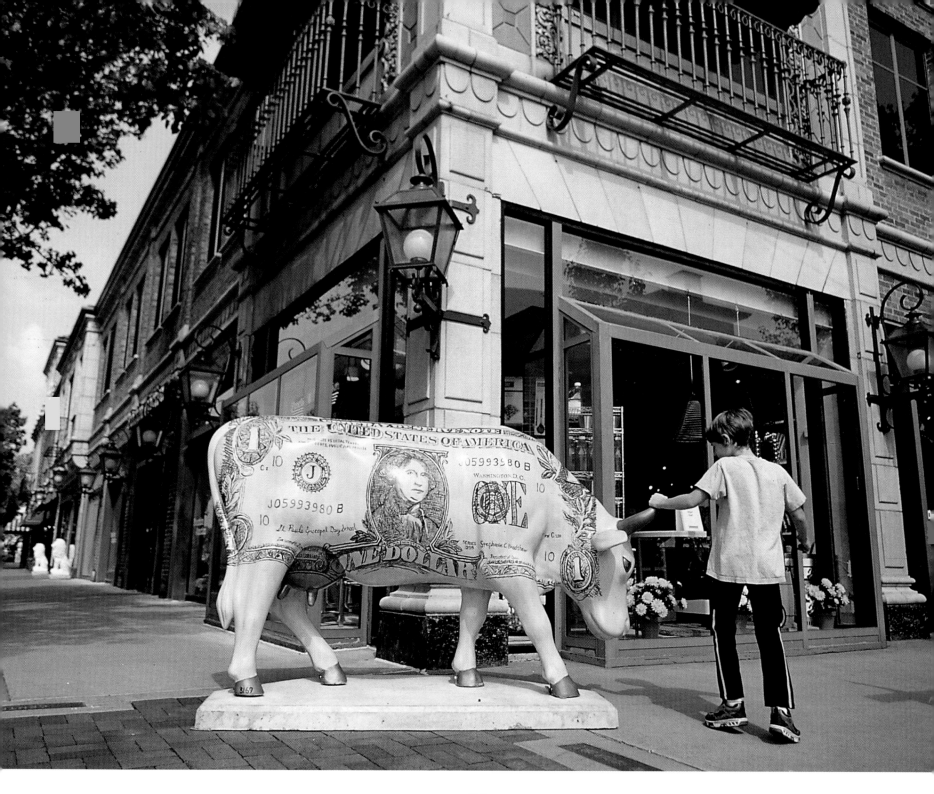

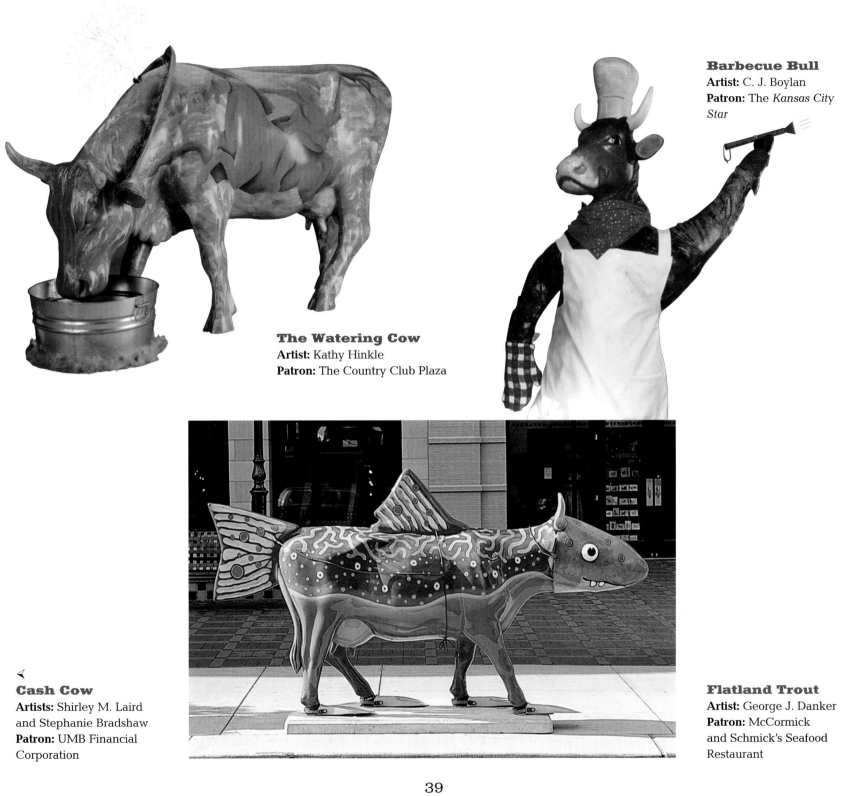

Barbecue Bull
Artist: C. J. Boylan
Patron: The *Kansas City Star*

The Watering Cow
Artist: Kathy Hinkle
Patron: The Country Club Plaza

Cash Cow
Artists: Shirley M. Laird
and Stephanie Bradshaw
Patron: UMB Financial
Corporation

Flatland Trout
Artist: George J. Danker
Patron: McCormick
and Schmick's Seafood
Restaurant

Moody Blue

Artist: Joe Bill Breeden
Patron: UMB Financial Corporation

Trojan Cow

Artist: Donald L. Ross "Scribe"
Patron: Houlihan's

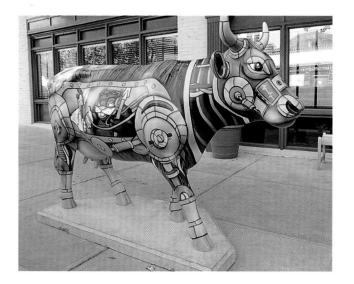

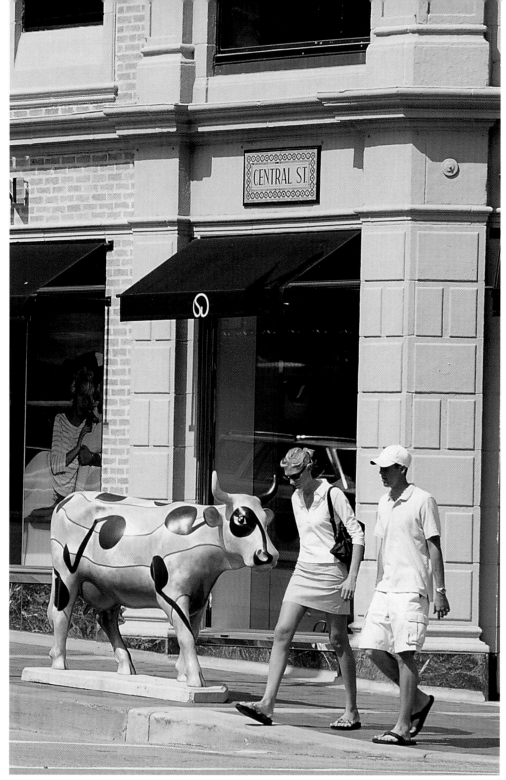

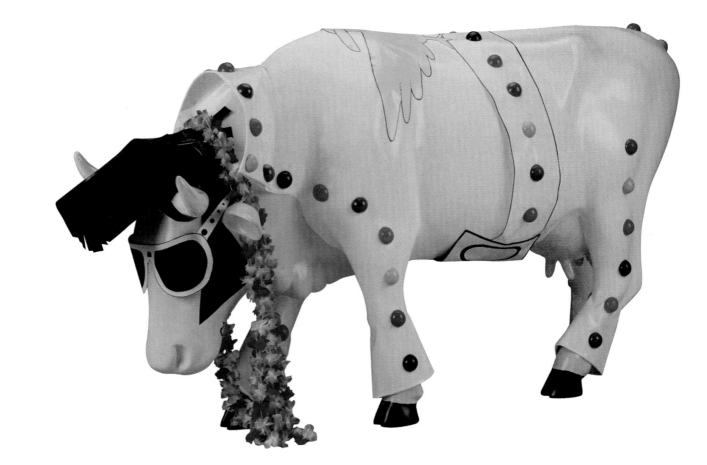

Cowlvis
Artist: Charlie Podrebarac
Patron: Plaza Merchants Association

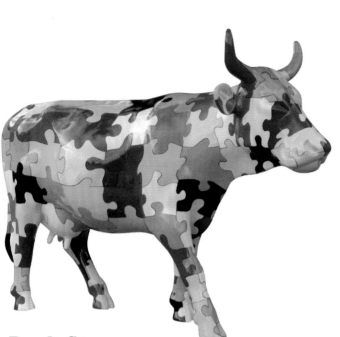

Puzzle Cow
Artist: Candida Bayer
Patron: CowParade

Cowculus
Artist: Carrie Cronan
Patron: The *Kansas City Star*

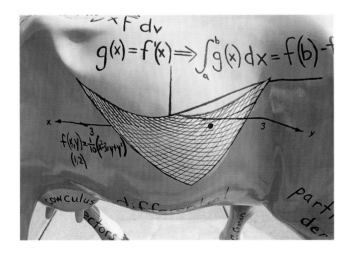

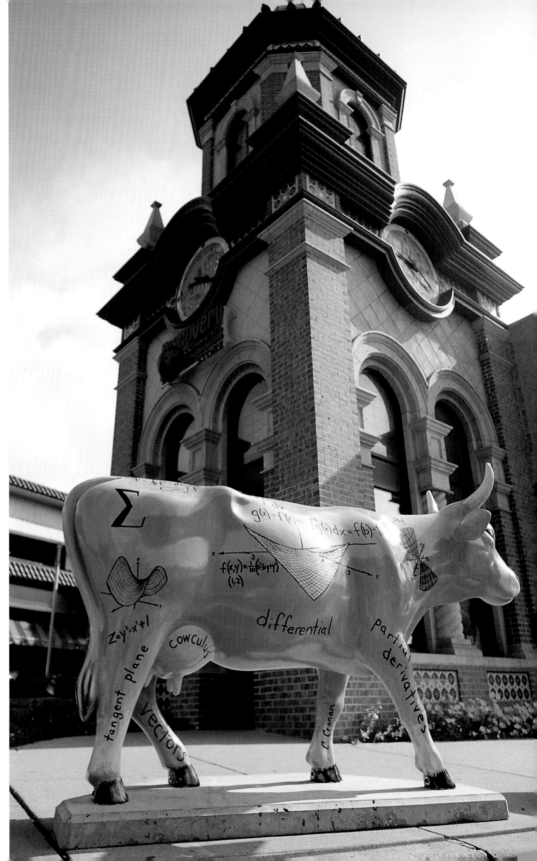

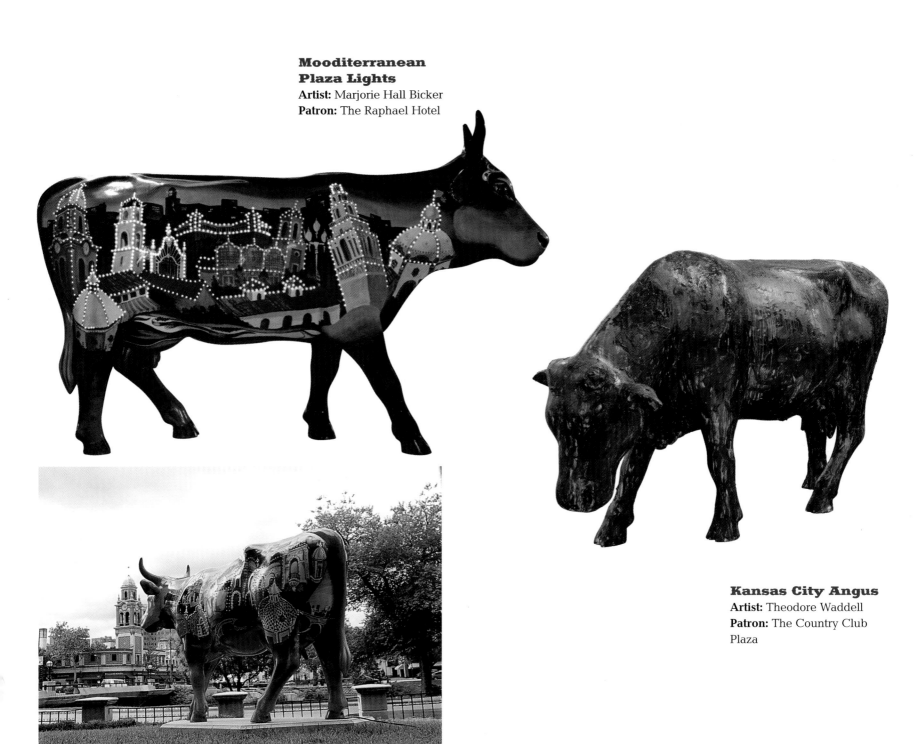

**Mooditerranean
Plaza Lights**
Artist: Marjorie Hall Bicker
Patron: The Raphael Hotel

Kansas City Angus
Artist: Theodore Waddell
Patron: The Country Club
Plaza

43

Crown Center

Crown Center Plaza is a tribute to an all-American go-getter. Joyce C. Hall was a kid of 18 when he arrived in Kansas City from Nebraska. In his luggage were a couple of shoe boxes packed with picture postcards. His first "office" was his room at the YMCA.

Hall started out peddling his cards to Kansas City drugstores, bookstores, and gift shops. Selling picture postcards was a decent start-up business, but Hall was convinced there was a market for higher-end greeting cards—especially for Christmas and Valentine's Day—that could be mailed in envelopes.

By 1915, J.C., along with his brothers Bill and Rollie, had founded Hall Bros. They were printing their own greetings cards in their own plant. It was the beginning of Hallmark.

Hall was a visionary. He invented the name "Hallmark" and insisted it be placed on the back of every card his company printed (the name and crown logo have become one of the world's most widely recognized trademarks). He sponsored the *Hallmark Hall of Fame* at a time when conventional wisdom said it was foolhardy for corporations to sponsor television (in 50 years, the Hallmark programs have won 80 Emmys). And when the area surrounding Hallmark's corporate headquarters went into decline, J.C. developed a neighborhood renewal plan that brought residences, offices, and hotels back to the Crown Plaza vicinity.

MOO-Maid
Artist: Hallmark Creative Workshop Group & Innovations Research and Development
Patron: Crown Center

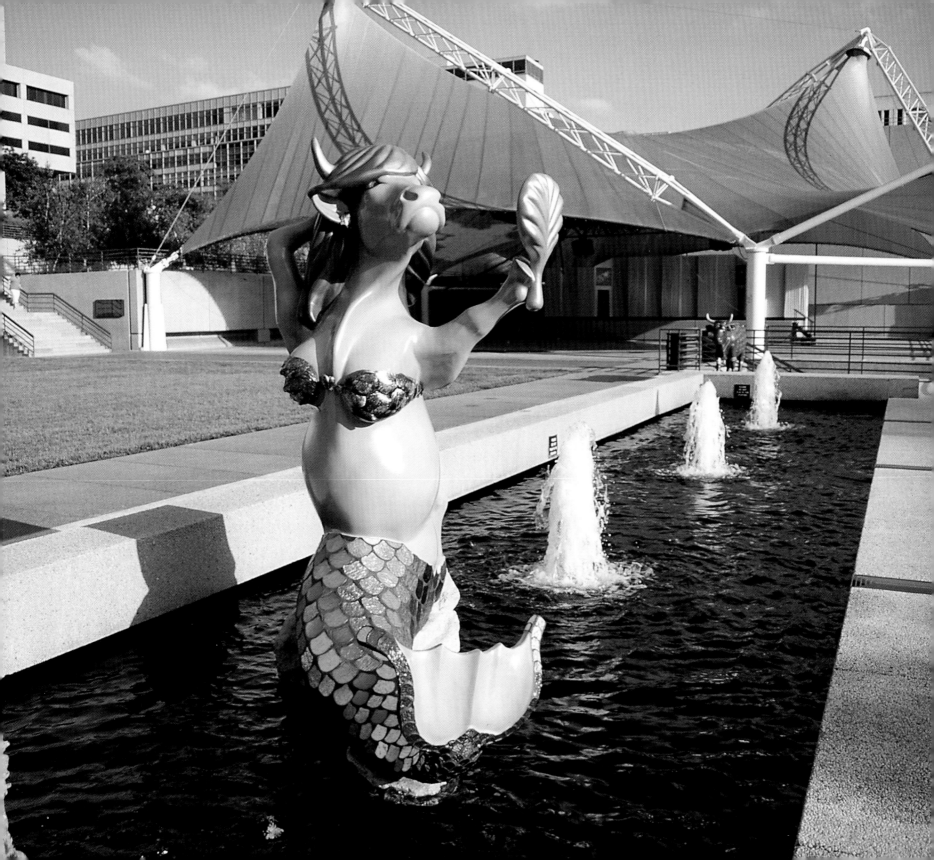

La Vache Effleure

Artist: Jill McDonald,
Hallmark Gifts &
Celebrations
Patron: Crown Center

Charlie Parcow

Artist: Harv Gariety, Hallmark
Design Photography
Patron: Crown Center

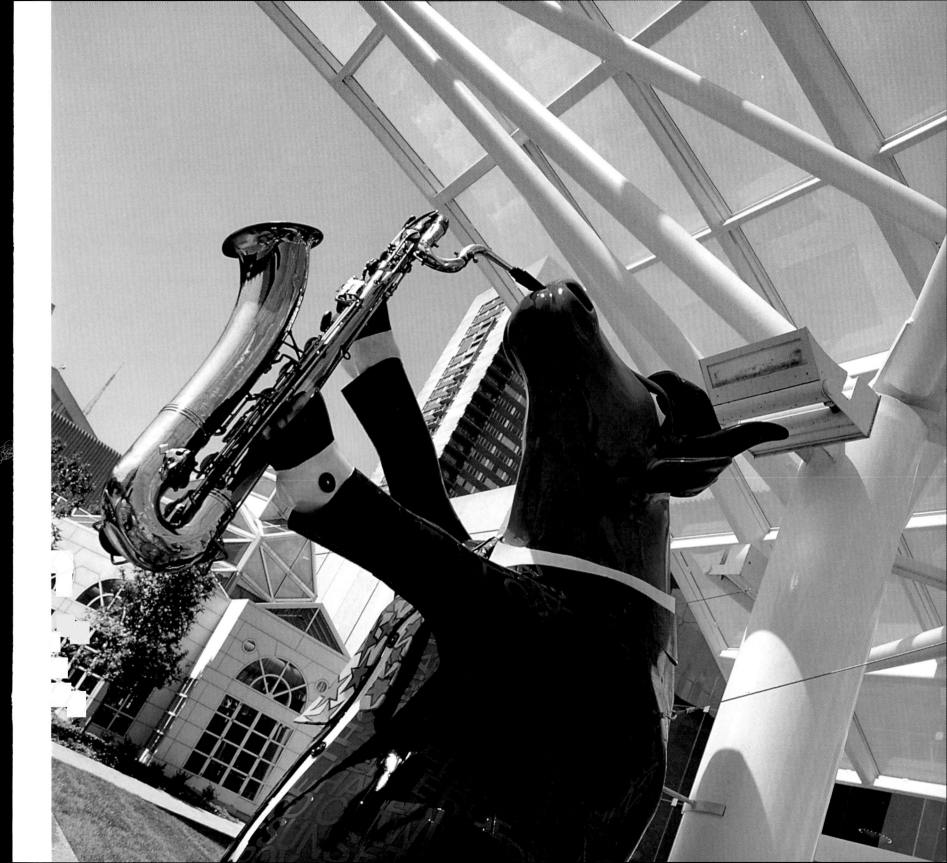

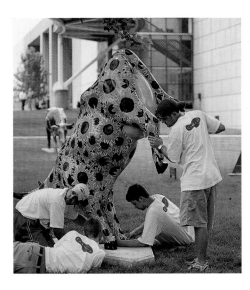

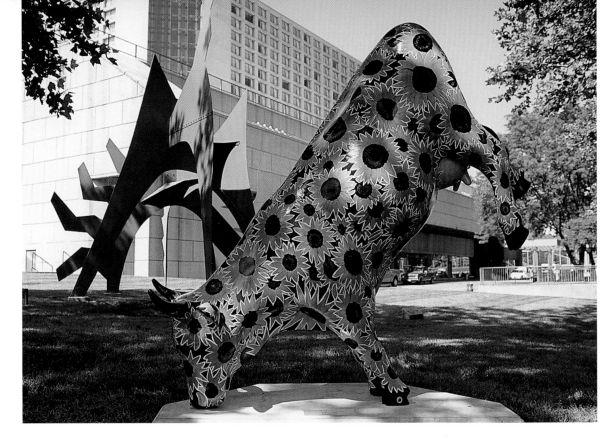

**Tipped
Kansas Cow**
Artist: Bill McCall
Patron: Yellow
Corporation

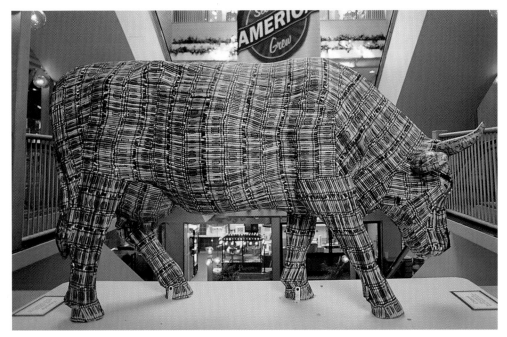

Cowyola
Artist: Lindsey Ross at Blue
Valley North High School
Patron: Crown Center

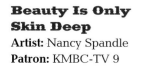

Beauty Is Only Skin Deep
Artist: Nancy Spandle
Patron: KMBC-TV 9

COWlligraphy
Artist: Hallmark Lettering Studio Artists
Patron: Crown Center

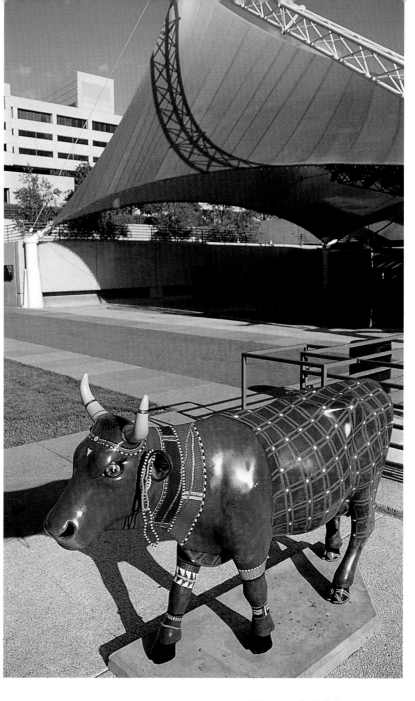

Maasai Africow
Artist: Cathi Cackler-Veazey
Patron: UMB Financial Corporation

51

American Royal
Artist: Asher B. Johnson
Patron: Fleishman-Hillard
International Communication

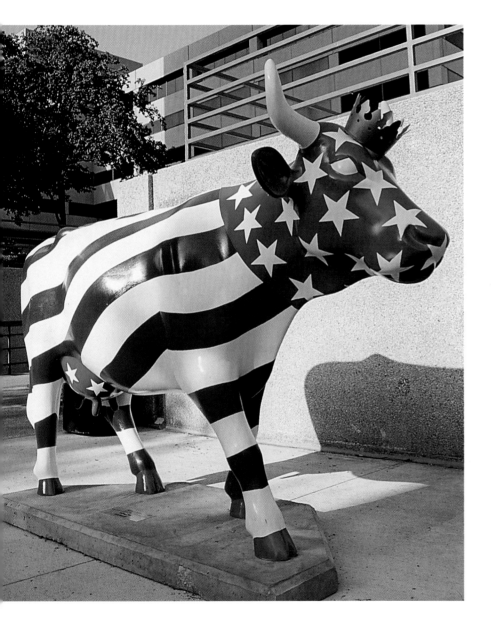

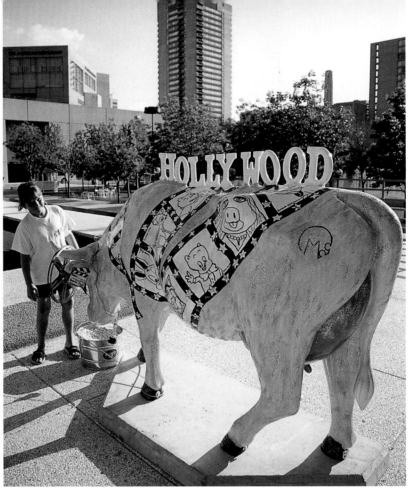

Moo-vie Star Cow
Artist: Brookridge
Elementary School
Patron: Crown Center

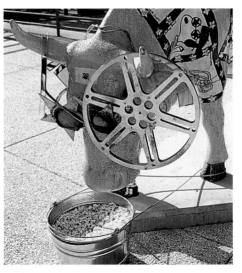

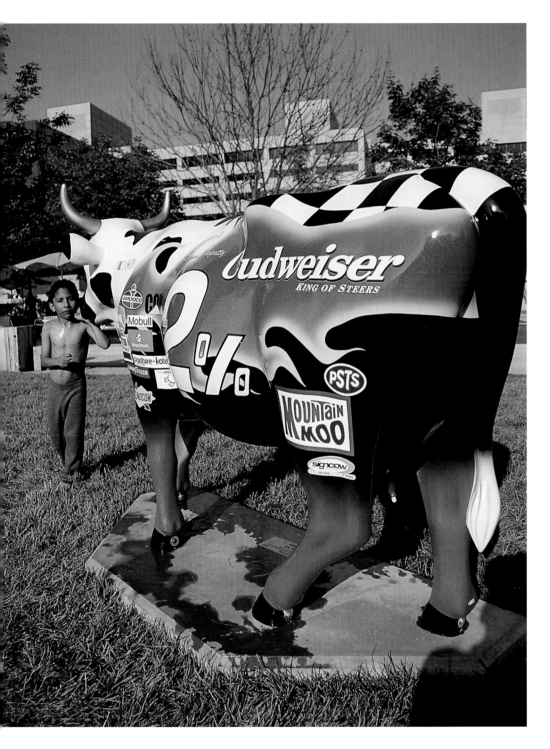

Cow-Motion
Artist: Cecilia Marie Raab
Patron: Crown Center

NASCOW
Artist: Hallmark Licensing
Design Studio
Patron: Crown Center

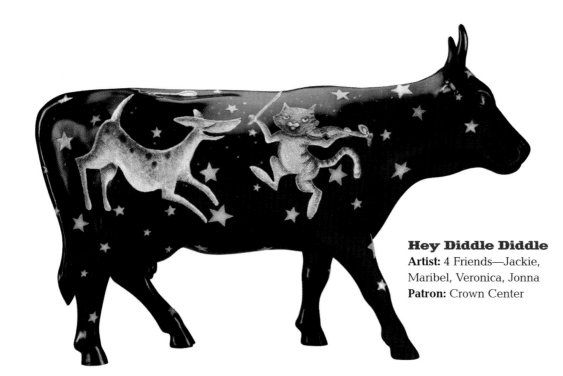

Hey Diddle Diddle
Artist: 4 Friends—Jackie,
Maribel, Veronica, Jonna
Patron: Crown Center

On VaCOWtion
Artist: Melissa Ingram
Patron: Color Mark
Printing Company

Cowch
Artist: Mark Cordes,
Hallmark New Business
Patron: Crown Center

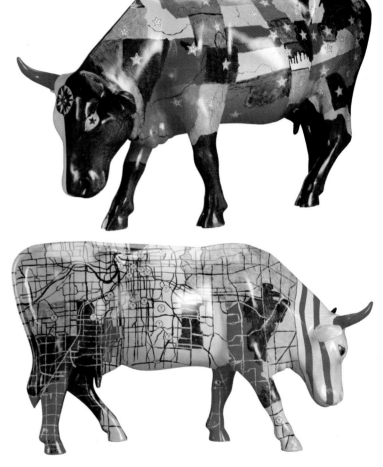

KC MAP Cow
Artist: St. Paul's Episcopal
Day School (C. Sloan)
Patron: Crown Center

Sock Monkey Cow
Artist: Sandra Walter Spencer
Patron: Crown Center

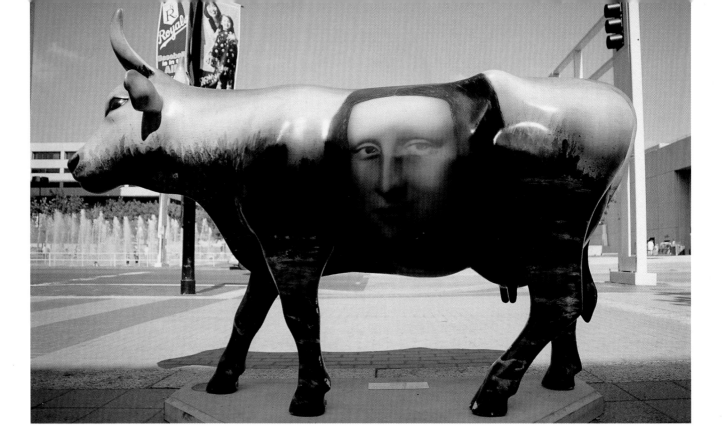

Moona Lisa Meets Moondrian

Artist: Robert Anderson
Patron: Reckson Associates Realty Corporation

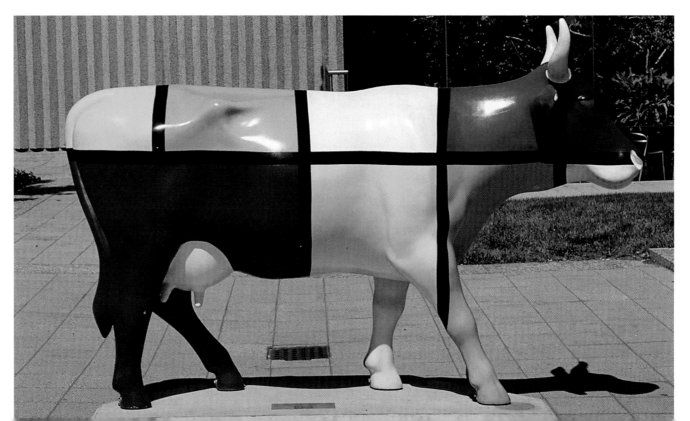

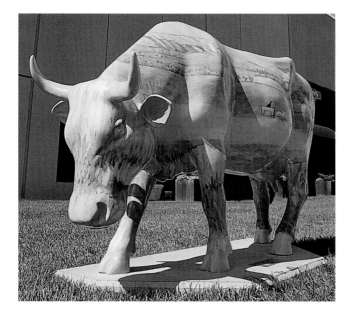

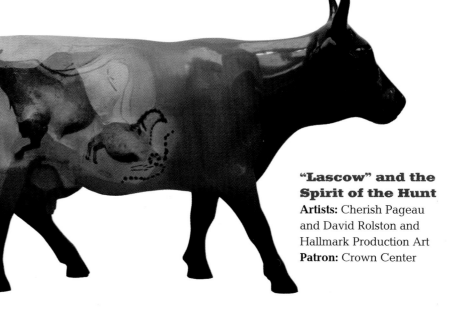

Art of America
Artist: Cynthia Hudson
Patron: Friends of the Kemper
Museum of Contemporary Art

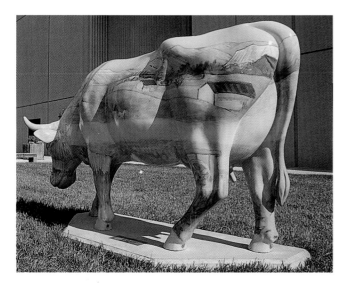

Vincent Van Cogh
Artist: Diana Freeman-Shea
Patron: CowParade

"Lascow" and the Spirit of the Hunt
Artists: Cherish Pageau
and David Rolston and
Hallmark Production Art
Patron: Crown Center

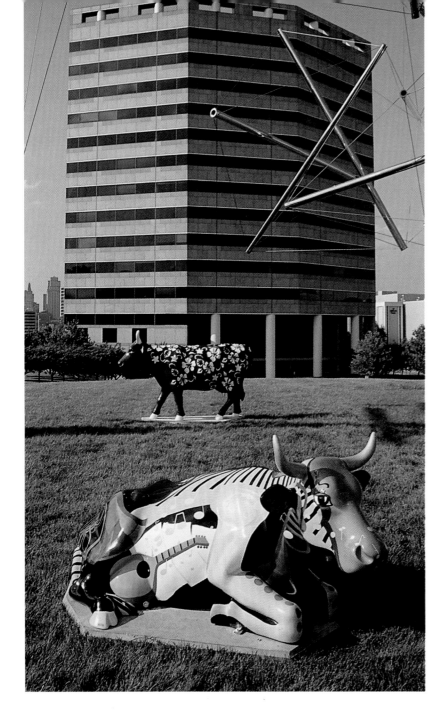

Jazz Cow
Artists: Janet Satz and Jan Gaumnitz
Patron: Crown Center

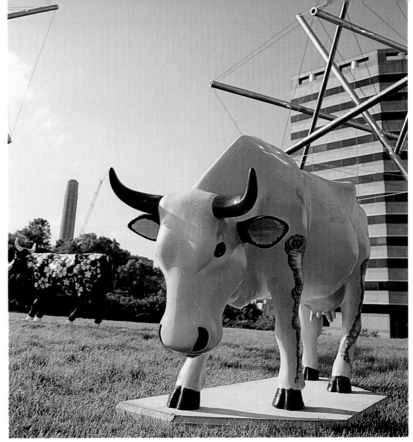

**Miss Mid-
American Moo Oz**
Artist: Ruby Dunham
Patron: KMBC-TV 9

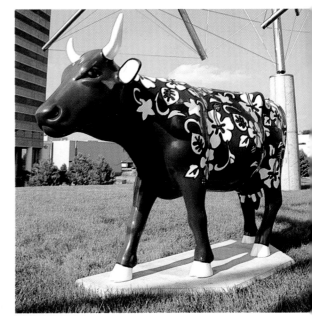

Cowabunga
Artist: Jamie Buck
Patron: Kansas City
Parks and Recreation

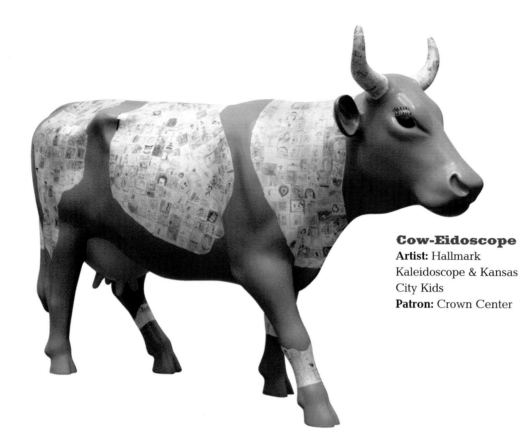

Cow-Eidoscope
Artist: Hallmark
Kaleidoscope & Kansas
City Kids
Patron: Crown Center

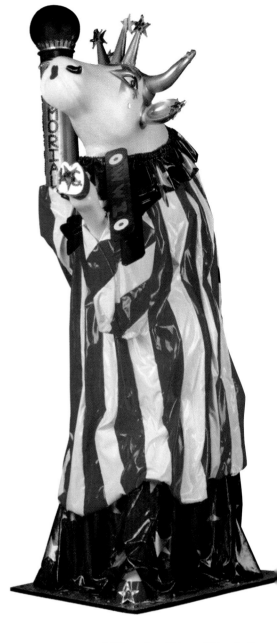

**Day & Night in
a Cow Town**
Artists: Gary Keshner and
A. Lloyd Dupont
Patron: Blue Cross and
Blue Shield of Kansas City

Liberty Moo-Morial
Artist: Sue E. Smith
Patron: The *Kansas City Star*

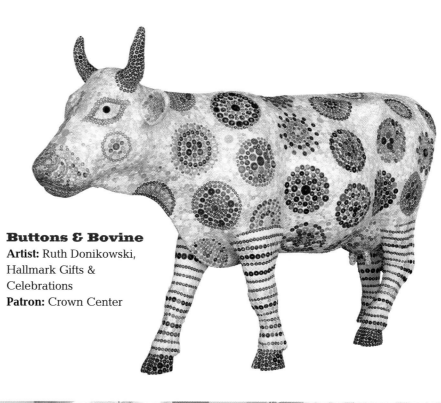

Buttons & Bovine
Artist: Ruth Donikowski,
Hallmark Gifts &
Celebrations
Patron: Crown Center

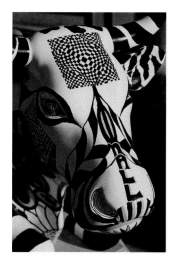

Cow Optical
Artist: Nall Hills
Elementary School
Patron: Crown Center

➢
CowZilla
Artist: Hallmark Planet
Humor Artists
Patron: Crown Center

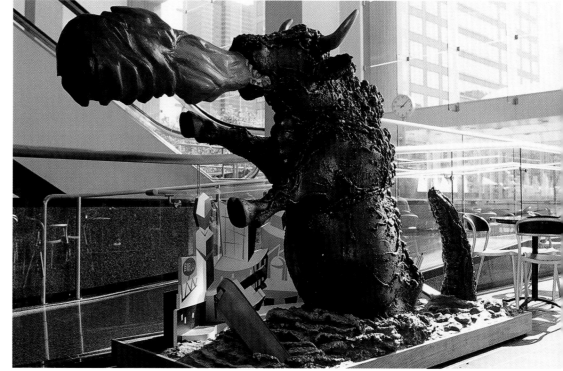

Hospital Hill

The Children's Mercy Hospital—in fact, the entire vast Hospital Hill complex—began with a single act of compassion. Back in 1897 two sisters, Dr. Alice Berry Graham, a dentist, and Dr. Katharine Berry Richardson, a physician, picked up a lame five-year-old girl who had been abandoned on the streets near the Kansas City stockyards. They found the child a bed in a small hospital downtown, and over time, thanks to surgery and physical therapy, the girl learned to walk.

Today, in addition to being the home of Children's Mercy, Hospital Hill is the site of the University of Missouri–Kansas City School of Medicine, two of its primary teaching hospitals, and the Truman Medical Centers. This hospital complex serves residents from six surrounding states and attracts patients from every corner of America.

**Terms of
Ensteerment**
Artist: Brenda Joiner-Nasca
Patron: Truman Medical
Centers

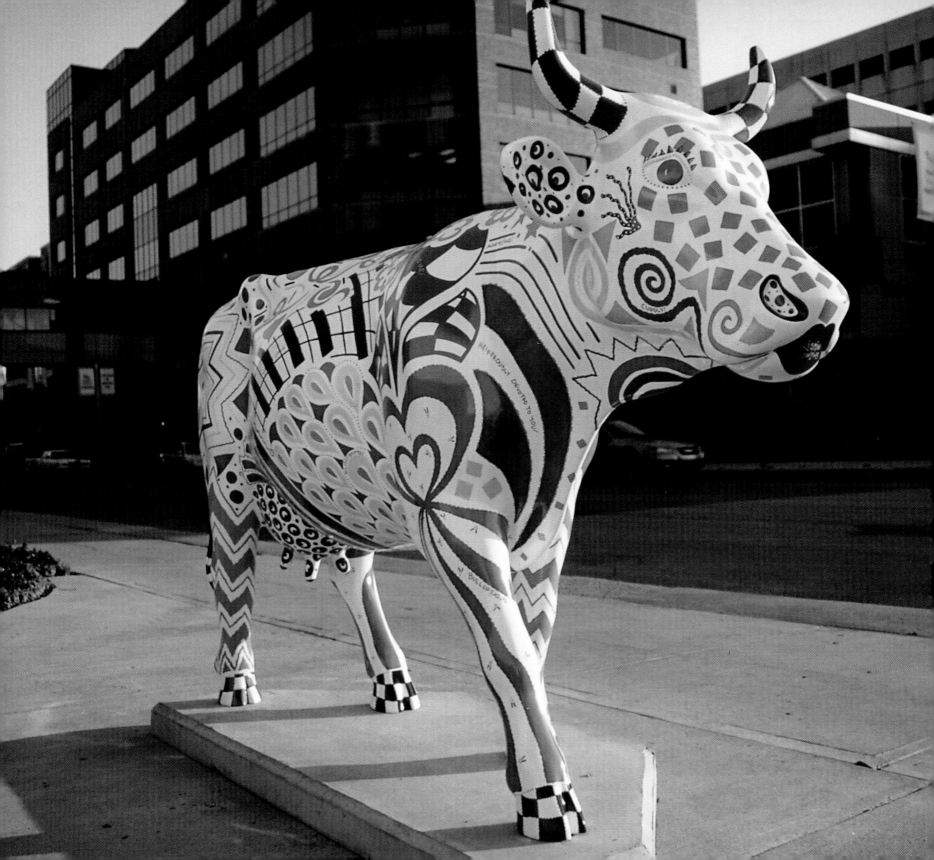

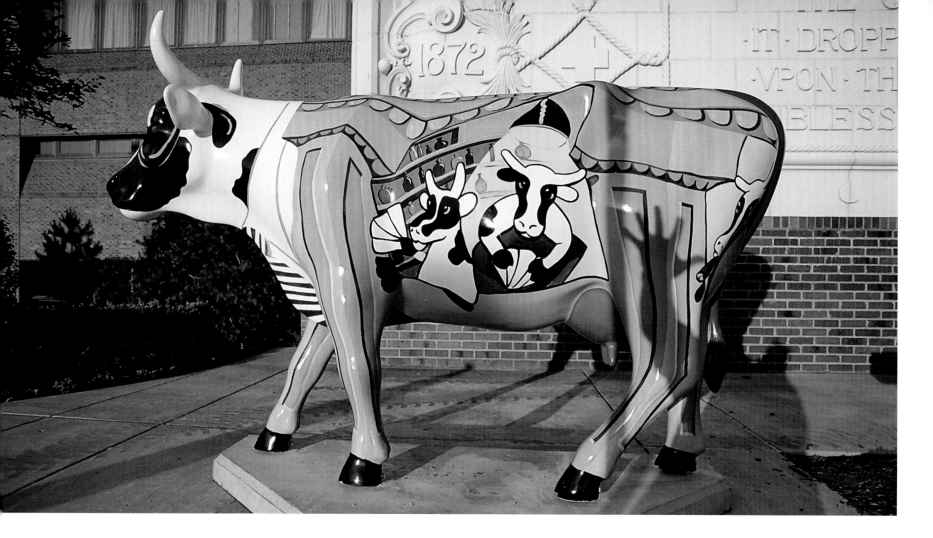

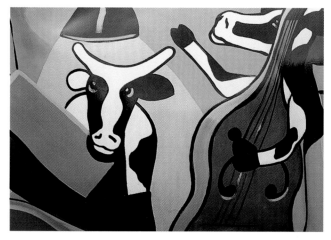

◄ ʌ

Moo Kid in Town
Artist: Thomas Street
Studios, LTD
Patron: CowParade

64

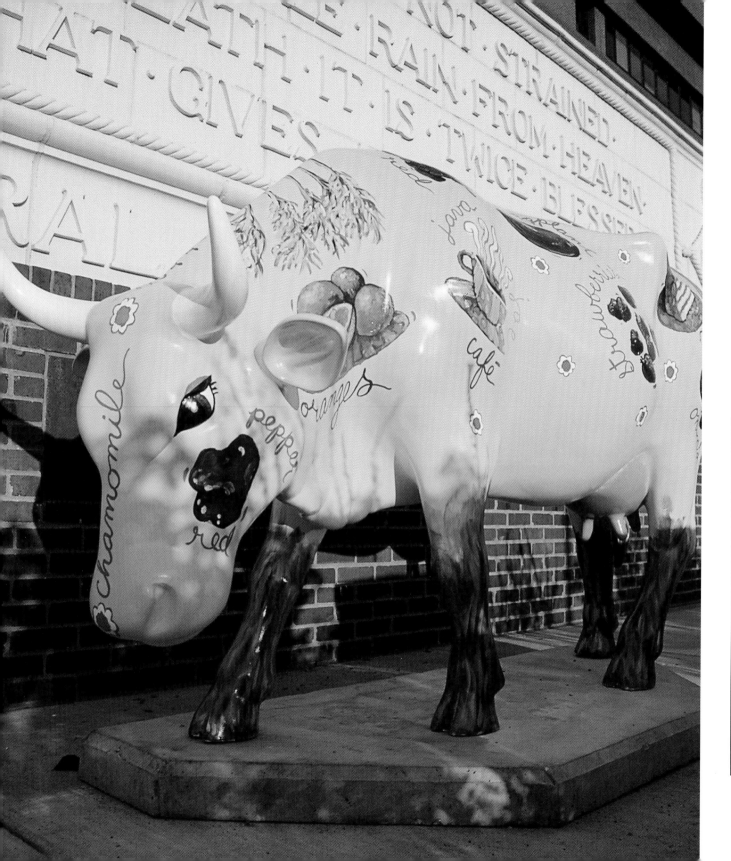

More Than Just Meat
Artist: Kristin Dempsey
Patron: Truman Medical Centers

Union Station

The original Union Station stood in West Bottoms, where it served as the hub of Kansas City's railroad traffic. It had been designed by a young architect, William E. Taylor, in what was described as "Renaissance style and Frenchy." The cupolas, dormers, and gingerbread ornamentation gave the station dignity, but even the most Frenchified architecture could not improve its disreputable West Bottoms neighborhood. Since the saloons and houses of ill repute that surrounded Union Station showed no sign of moving out, the town fathers decided that the station would.

The campaign to build a new station began in 1897, but it took until 1909 for the new design—and the construction budget—to be approved. Five years later, on October 31, 1914, the new Union Station opened for business. It was the third-largest passenger terminal in the United States, exceeded only by New York City's Grand Central Terminal and Pennsylvania Station.

As airline and automobile travel replaced travel by rail, Union Station became neglected. Today, however, the station has come back to life as the spectacular home of Science City, a magnificent new museum of scientific exploration and discovery.

Moosaic Cow
Artist: Jean Goodman and Benninghoven Students
Patron: KMBC-TV 9

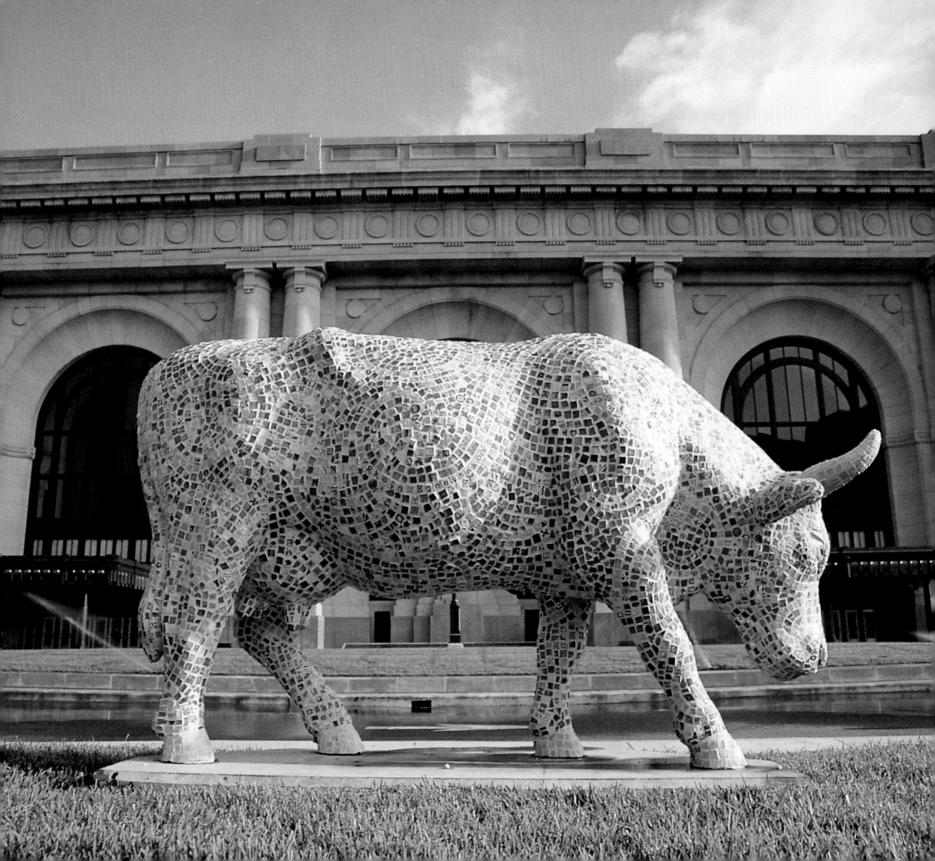

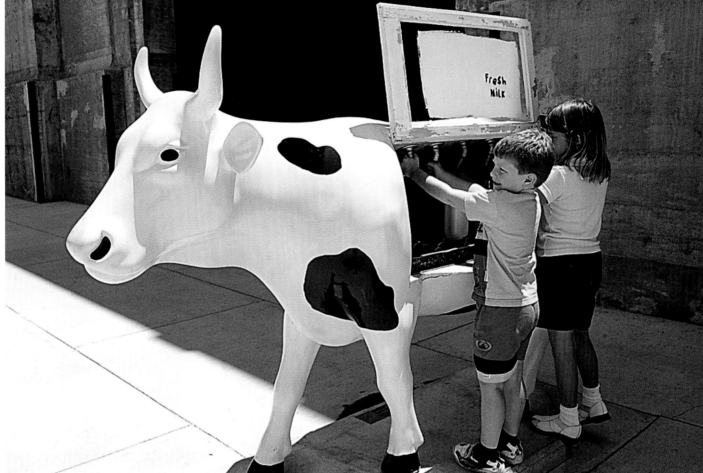

Fresh Milk
Artist: Steven Dana
Patron: CowParade

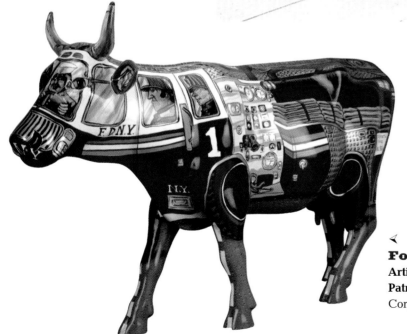

Four-Alarm Cow
Artist: Red Grooms
Patron: UMB Financial
Corporation

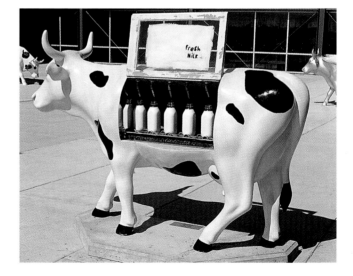

68

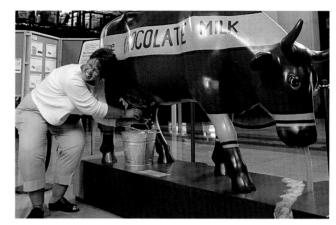

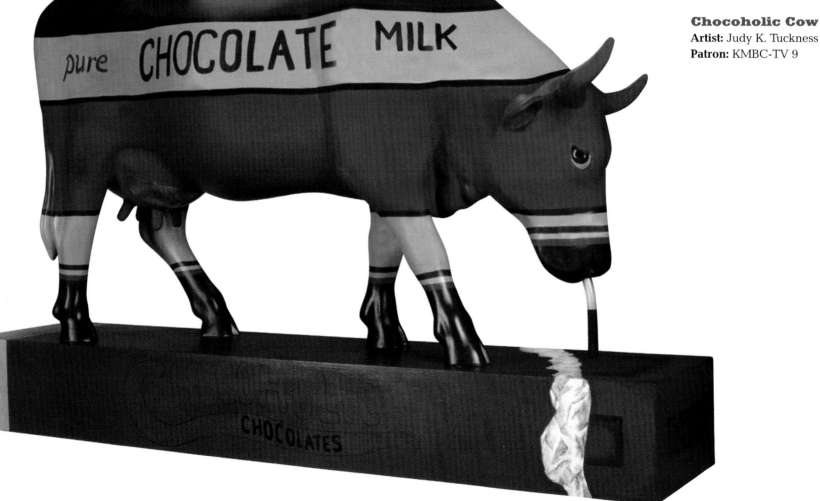

Chocoholic Cow
Artist: Judy K. Tuckness
Patron: KMBC-TV 9

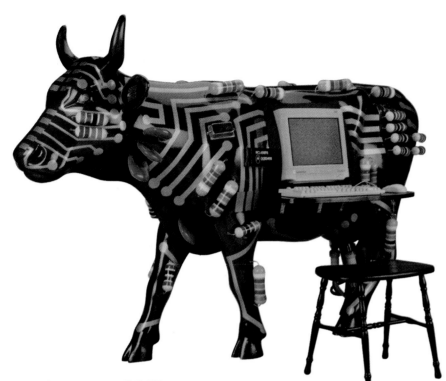

Cowputer 2001
Artist: Thomas M.
Edmondson
Patron: Worldspan, L.P.

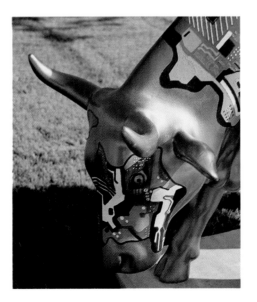

Electronic Cow
Artist: Liberty High
School
Patron: KMBC-TV 9

Afri-cow
Artist: *Crusader* Staff, Southeast African
Centered High School
Patron: The Star in Education

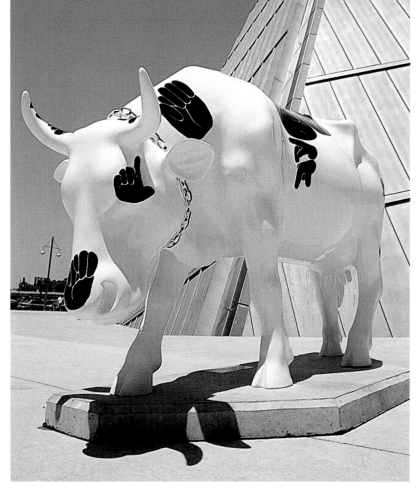

**Deaf Awareness—Visual
COWmunications**
Artist: Barbara Adams and the Students
of the Kansas School for the Deaf
Patron: Accenture

**I've Looked at
Cows from Both
Sides Now**
Artist: Mike Savage
Patron: Fahnestock and
Co., Inc.

71

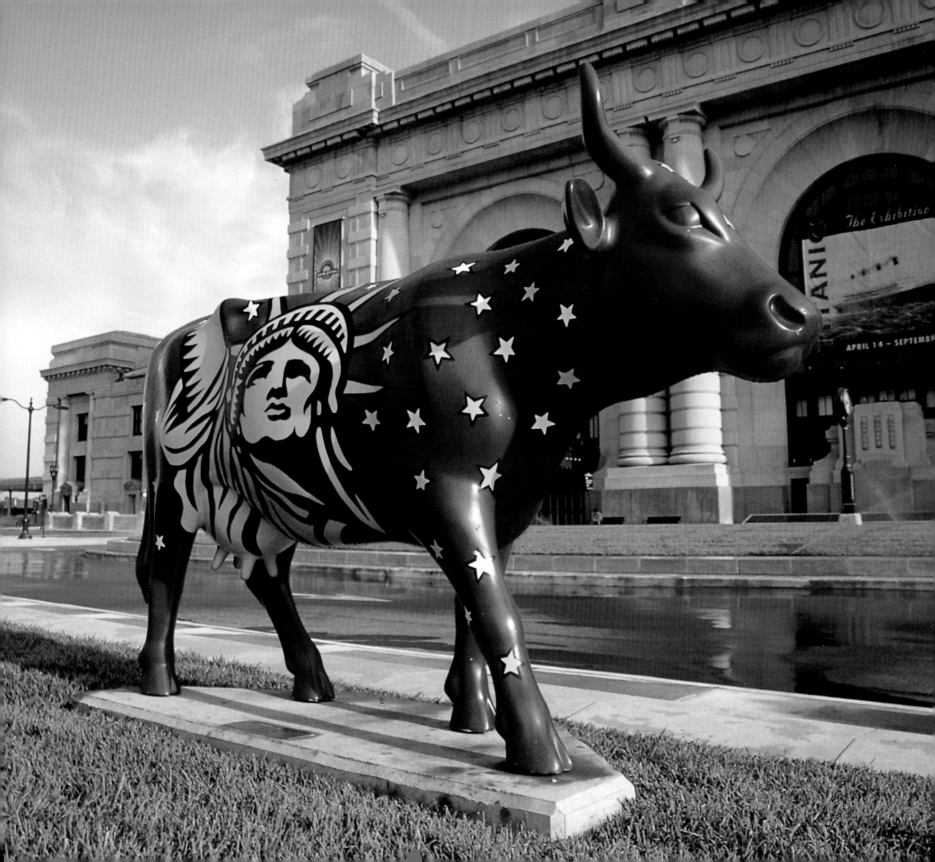

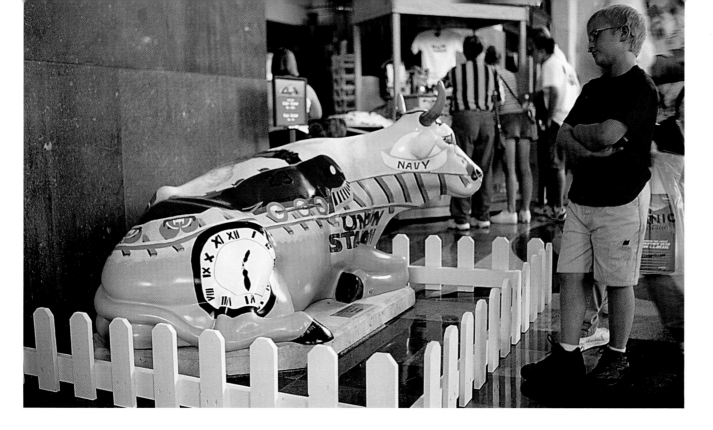

**Chugga Chugga
Moo Moo**
Artist: Jessara Wiley at
Fire Prairie Middle School
Patron: KMBC-TV 9

Liberty Cow
Artist: Burton Morris
Patron: CowParade

**Moondrian Sports
Period**
Artist: North Kansas City
High School Art
Department
Patron: MAI Sports

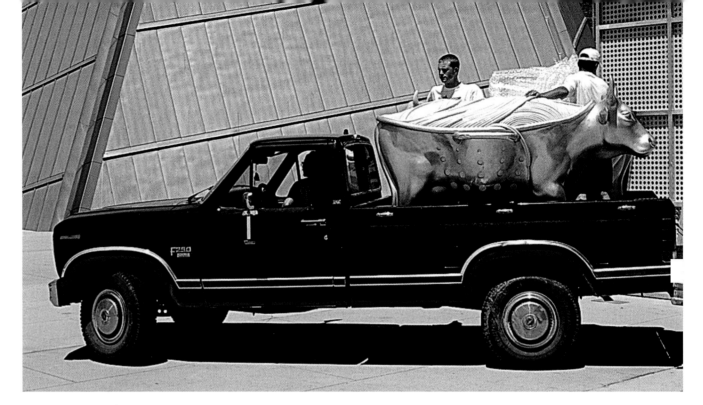

Cowlander
Artist: Caleb Freeman
Patron: Morningstar
Communications
Company

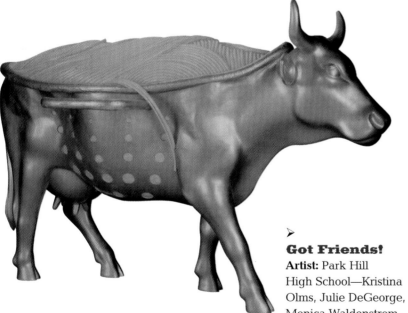

➤
Got Friends!
Artist: Park Hill
High School—Kristina
Olms, Julie DeGeorge,
Monica Waldenstrom,
Andrea Rinkel
Patron: City of Riverside,
Missouri

74

ShaMoo
Artist: Harmony Middle School
Patron: The Star in Education

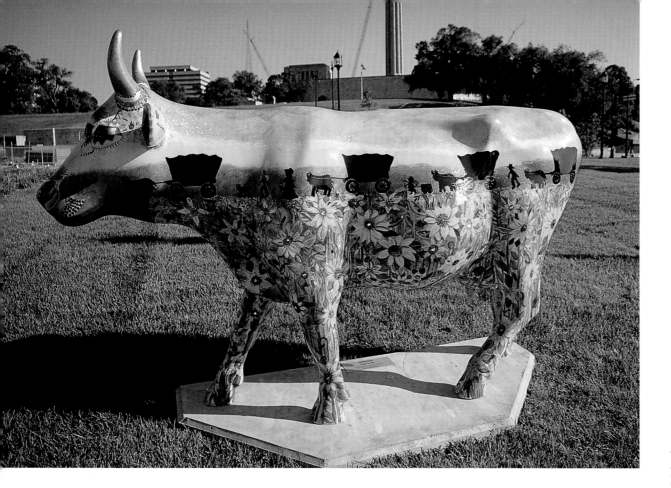

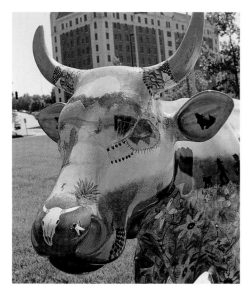

Westward Ho!
Artist: Warford
Elementary School
Patron: The Star in
Education

A Study in Still Life
Artist: McKenzie-Childs
Patron: CowParade

Buckle Up Betsy
Artist: Jeanette Parsons
and Lee's Summit North
High School
Patron: Lee's Summit
North High School

BUCKLE UP

Daisy's Dream
Artist: Randy Gilman
Patron: CowParade

Spirit of St. Louis
Artist: Chong Gon Byun
Patron: Fisher Brothers

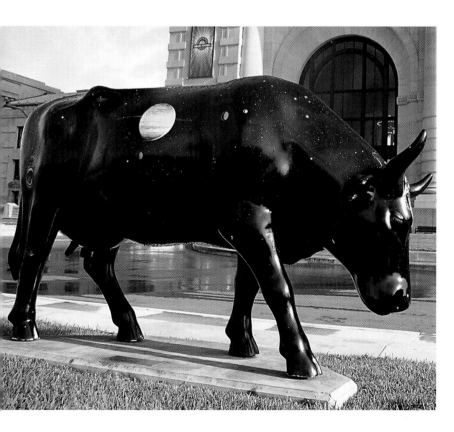

Washington Square Park, with its statue of George Washington on horseback, was dedicated in 1925. It is located across the street from Union Station, Liberty Memorial, and Crown Center.

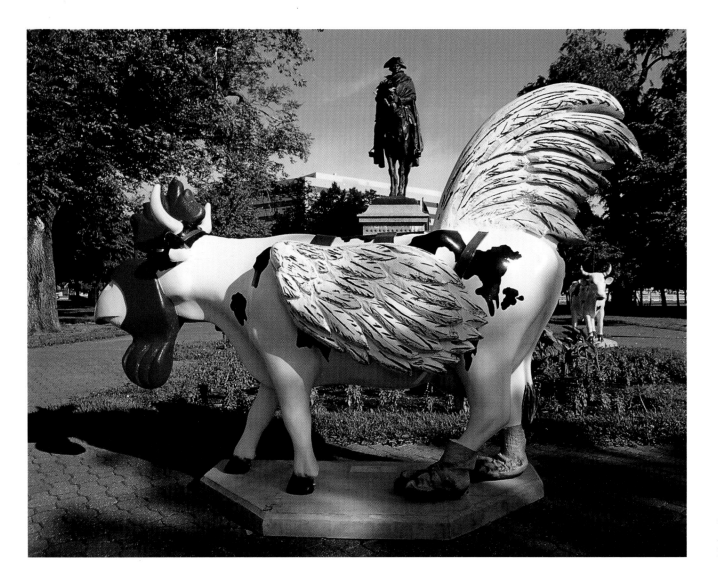

Cow-moo-flage
Artist: Adam Rini
Patron: Price Chopper

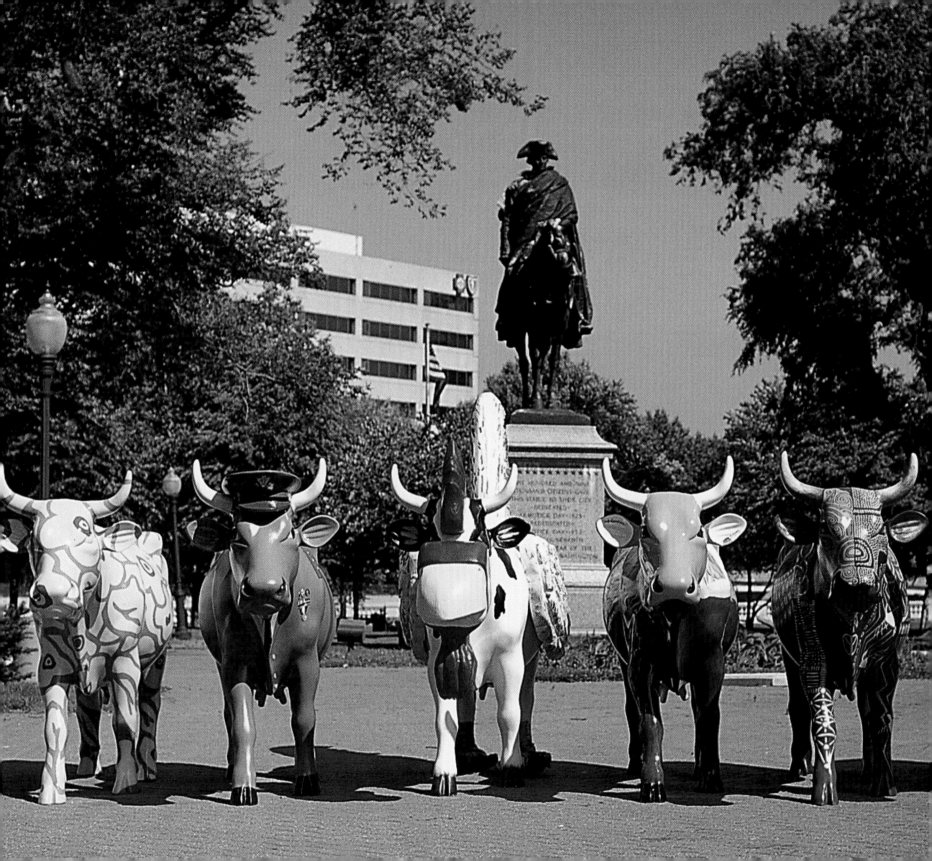

Light Blue Cow
Artist: Michael Graves
Patron: Target Stores

Daisy
Artist: Jan Wheeler
Patron: CowParade

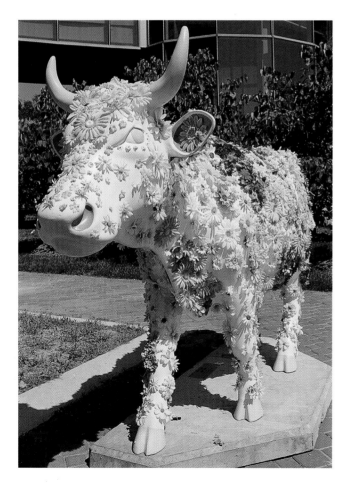

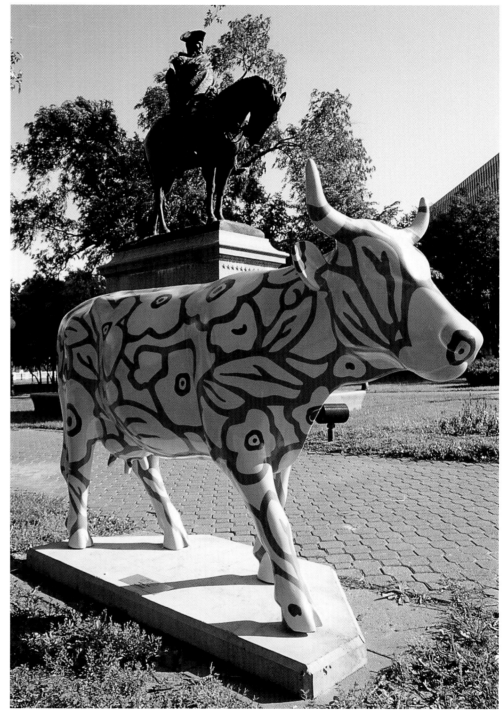

80

Beige Cow
Artist: Michael Graves
Patron: Target Stores

Marie Amooure
Artist: Betsy Pitman Curry
Patron: In honor of Ray
and Betty Pitman

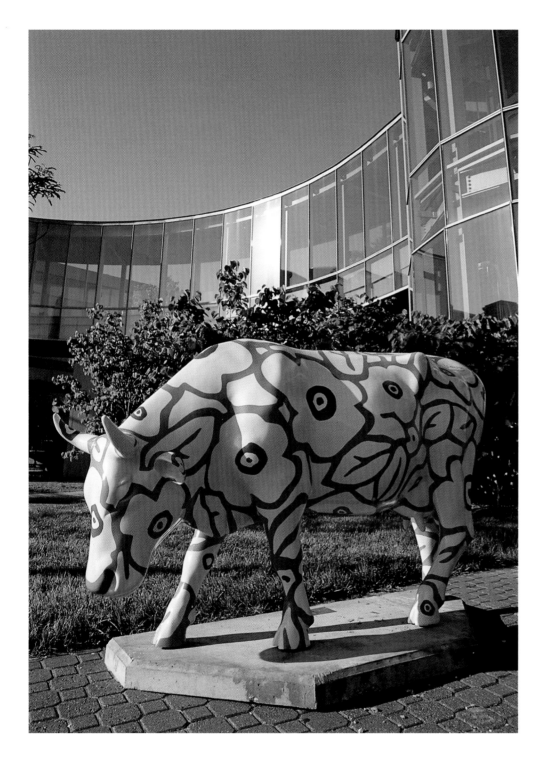

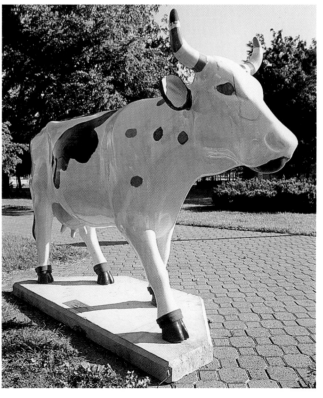

81

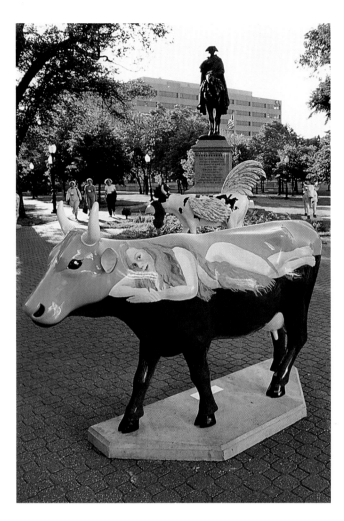

Liberty Moo-Morial Monument
Artist: Rindy Richerson
Patron: The Country Club Plaza

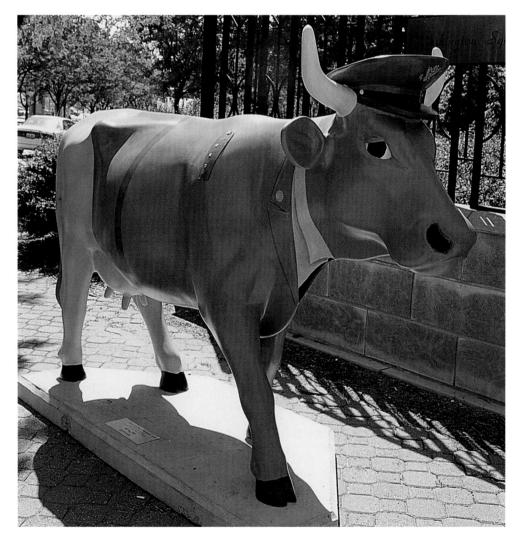

Lady Cow-diva
Artist: Suzanne Andersen
Patron: Hearst Corporation

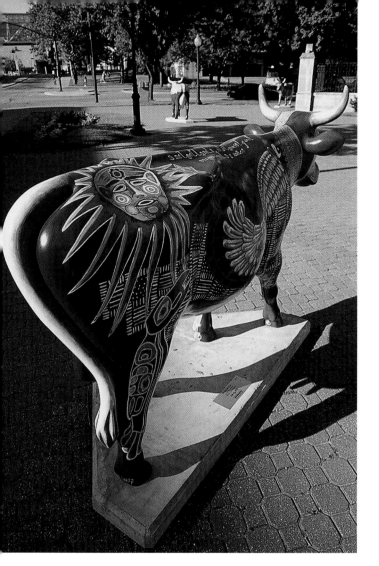

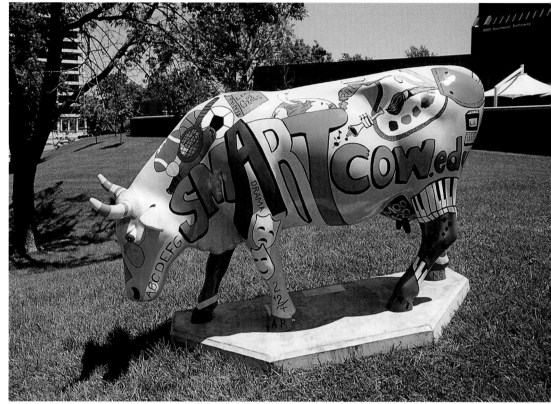

Penn Valley Community College

KC Sacred Cow
Artist: R.L. Miller
Patron: Camp David

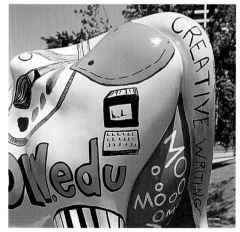

smARTcow.edu
Artists: Peggy O'Neill,
Julia Peterson, Andrea
Pantoja, Carin Ismert
Patron: Francis Families
Foundation

Kansas City Star

William Rockhill Nelson arrived in Kansas City in 1880, ready to publish a newspaper and make a difference to the city. He founded the *Kansas City Evening Star,* which his competitors at the *Kansas City Journal* and the *Kansas City Times* mocked as the "Twilight Twinkler." But the publishers of the *Journal* and *Times* weren't laughing for long. Nelson made a persuasive promise to his readers. He would deliver breaking news "of fires before the smoke has cleared, of murders before the body of the victim lies cold in death, and of weddings before the happy bride can collect her senses." And he undercut the competition by charging two cents for the *Star* (the other papers sold for a nickel). On September 21, 1888, after several name changes, the paper became simply the *Kansas City Star.*

Nelson saw himself as a crusading journalist, using his paper to campaign for a host of civic improvements in Kansas City: paved streets, sidewalks, street lights, sewers, a bigger police force, a larger fire department, even bicycle paths. His magnificent art collection formed the foundation of the Nelson-Atkins Museum of Contemporary Art.

Scarecow
Artist: Jeff A. Tackett
Patron: The *Kansas City Star*

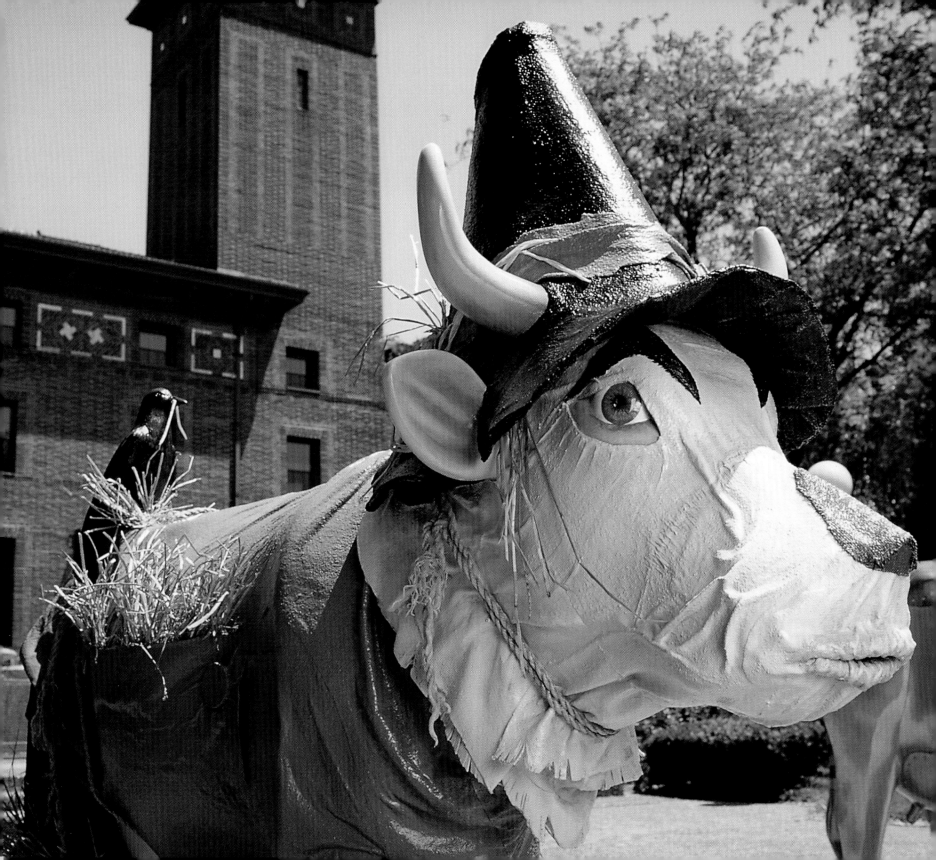

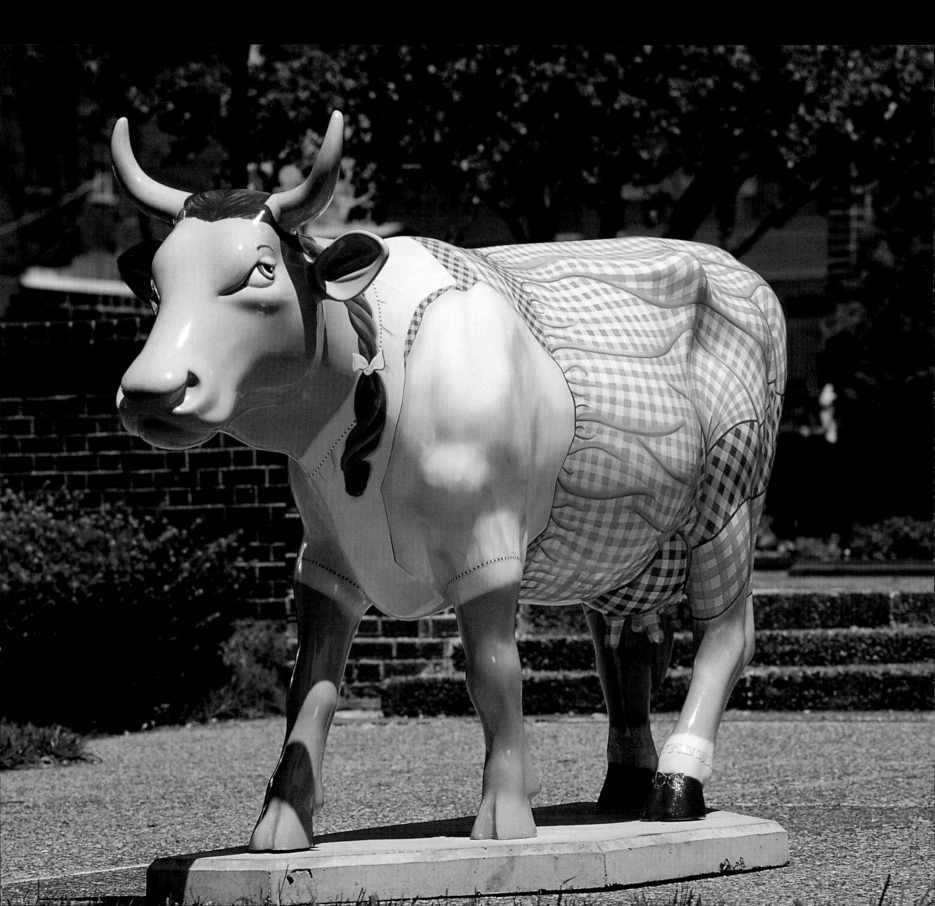

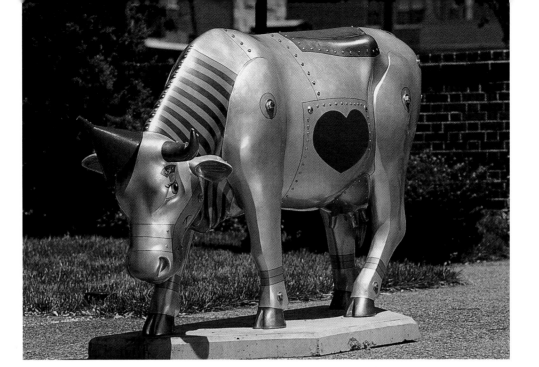

Tin Cow . . . from
The Wizard of OX
Artist: Dave Fisher
Patron: The *Kansas City Star*

< ∧
Dorothy
Artist: Candida Bayer
Patron: The *Kansas City Star*

Cowardly Lion
Artist: Jeff A. Tackett
Patron: The *Kansas City Star*

87

Downtown

Downtown is the birthplace of Kansas City. The Osage Indians lived here for centuries. The first European, Étienne Veniard de Bourgmont, passed through in 1713. Lewis and Clark spent three days here in 1804 on their historic expedition up the Missouri River to explore the Louisiana Purchase. At the old City Market, farmers sold produce from makeshift stands. On Quality Hill, the city's first moguls built their mansions. And here the Coates clan, one of Kansas City's most prominent families, built on opposite corners of Broadway their famous opera house and hotel.

After going through a rough period, Kansas City's Downtown is enjoying a renaissance thanks largely to young professionals who have moved into the neighborhood's lofts, town houses, and Victorian "painted ladies."

When Cows Fly
Artist: Denise DiPiazzo
Patron: Aquila Energy

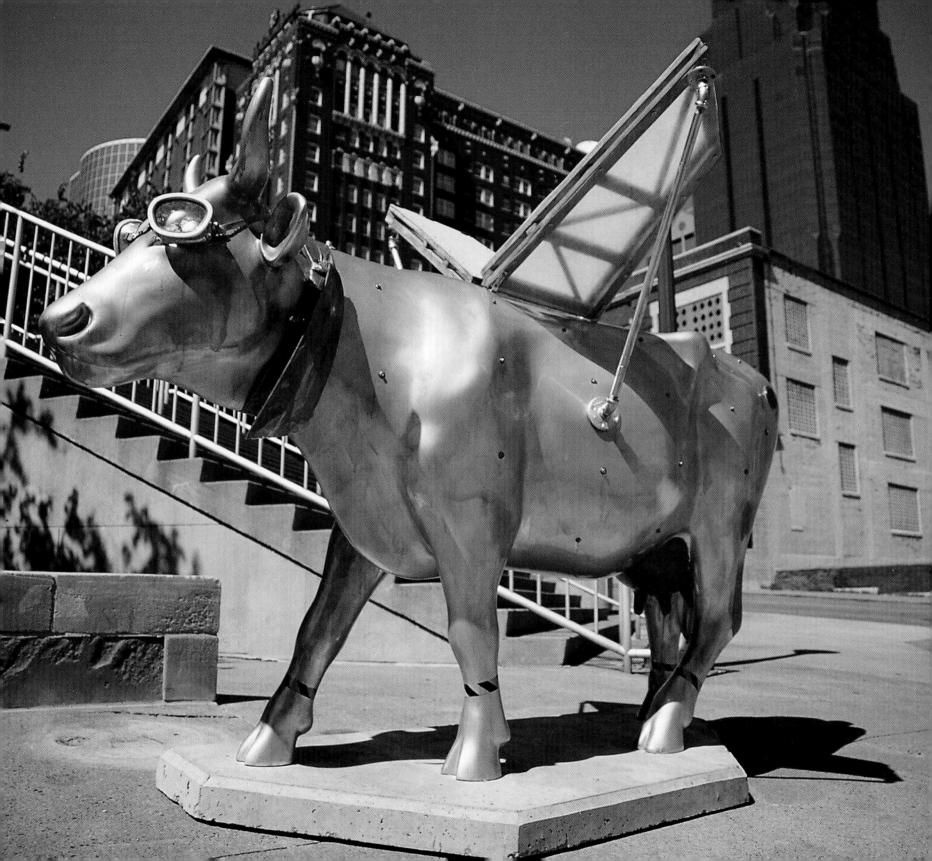

Cow Hands

Artist: Teri Siragusa Rattenne
Patron: Youth Friends, donated
by UtiliCorp United

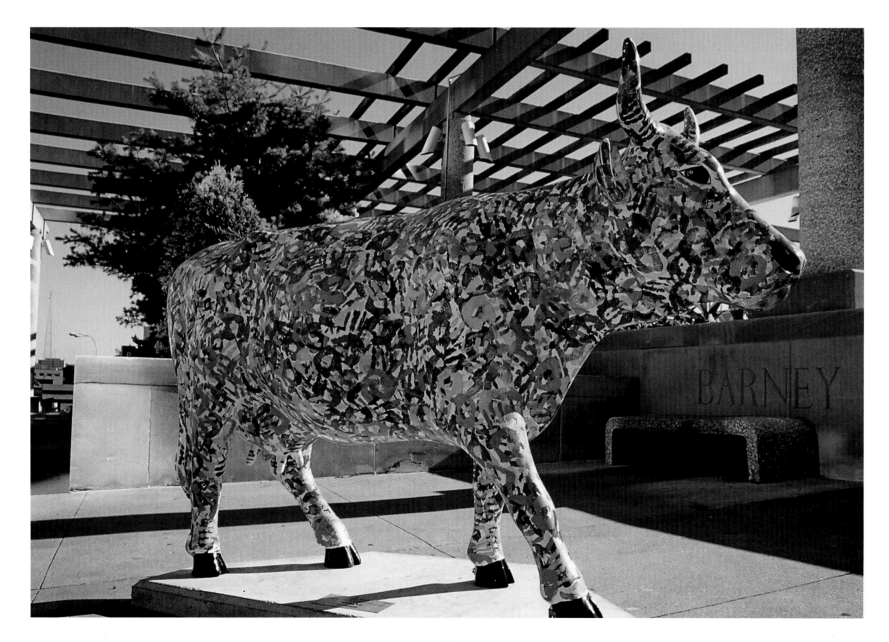

Jazz Mooosik
Artist: Ron Raymer
Patron: Kansas City Marriott
Downtown

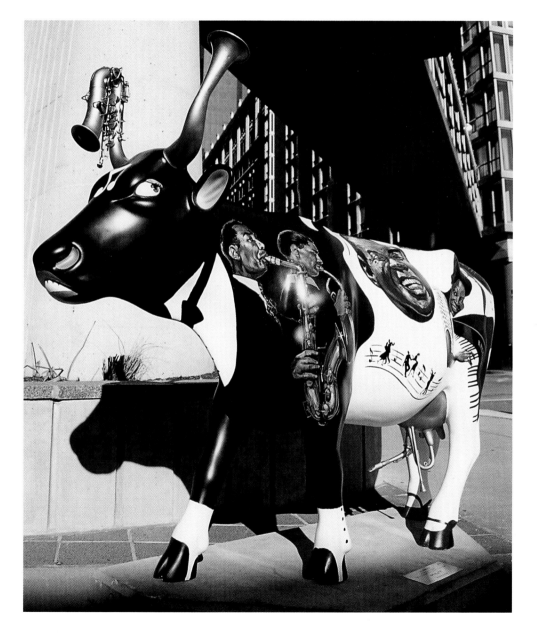

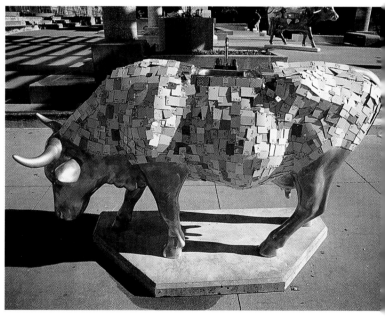

Cowntertop
Artist: Heinlein Schrock
& Stearns Architecture
Patron: Heinlein Schrock
& Stearns Architecture

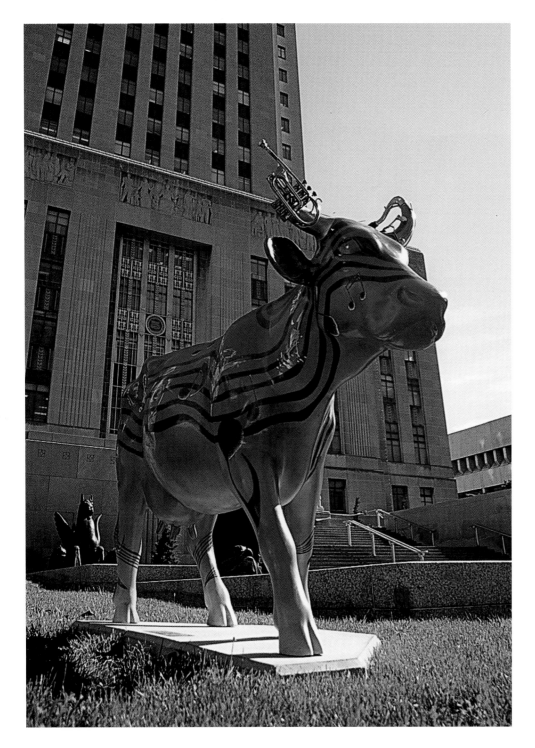

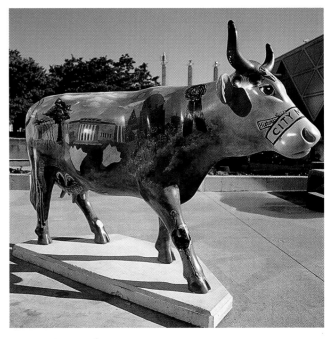

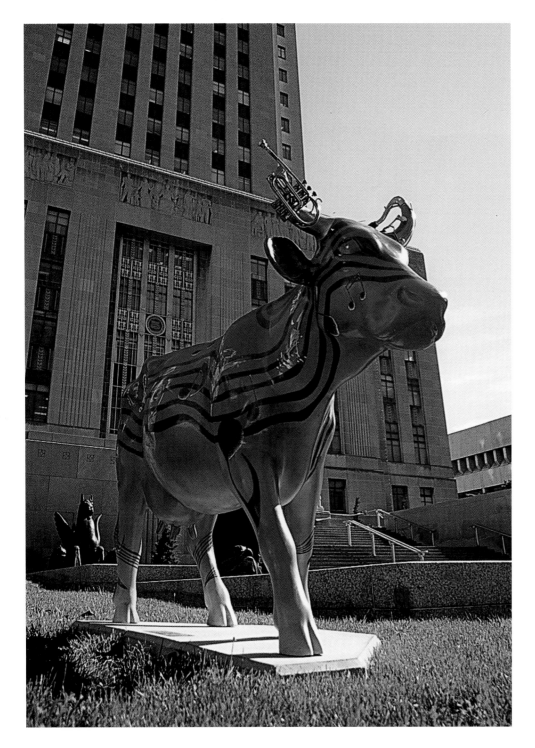

◄

**Cowsas City
Moos**
Artist: Wink
Patron: City of Kansas
City, Missouri

◄ ^

KC Cowsmopolitan
Artist: Mary Beth Rieke
Patron: Greater Kansas City
Convention and Visitors
Bureau

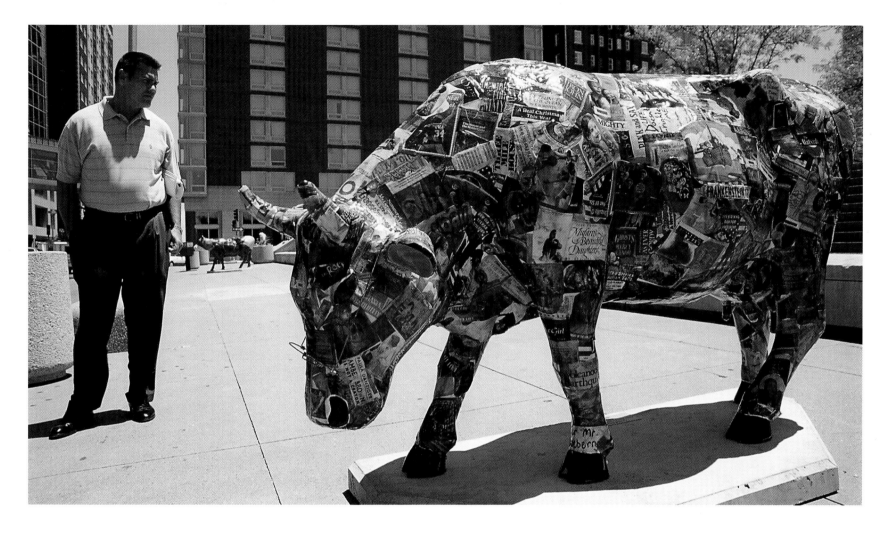

The Read Mooore Cow
Artist: J.A. Rogers
Academy
Patron: State Street Bank
and Trust Company

93

Moo-lyn Monroe
Artist: Allie Maxfield
Patron: Kansas City
Marriott Downtown

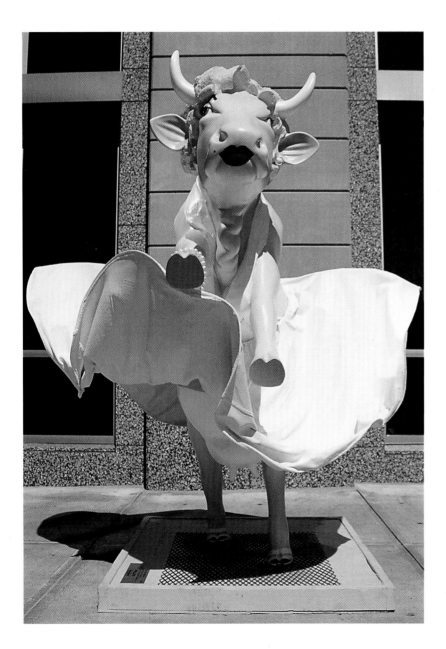
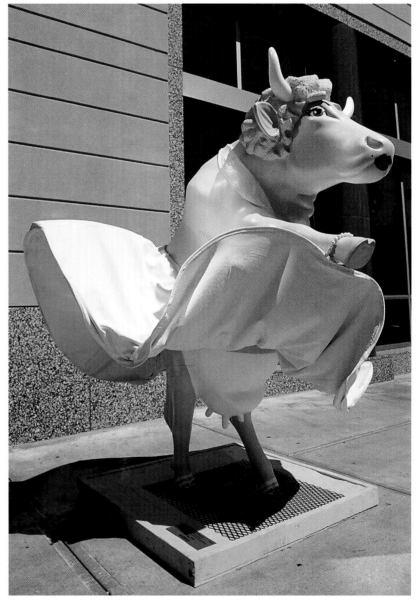

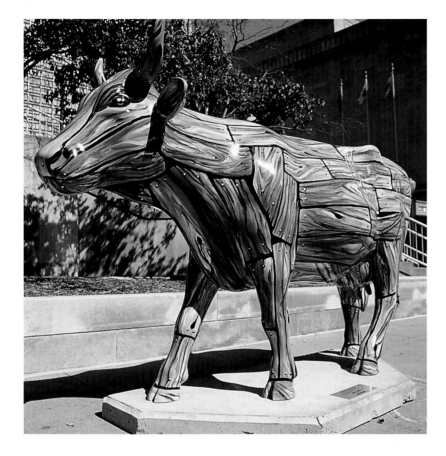

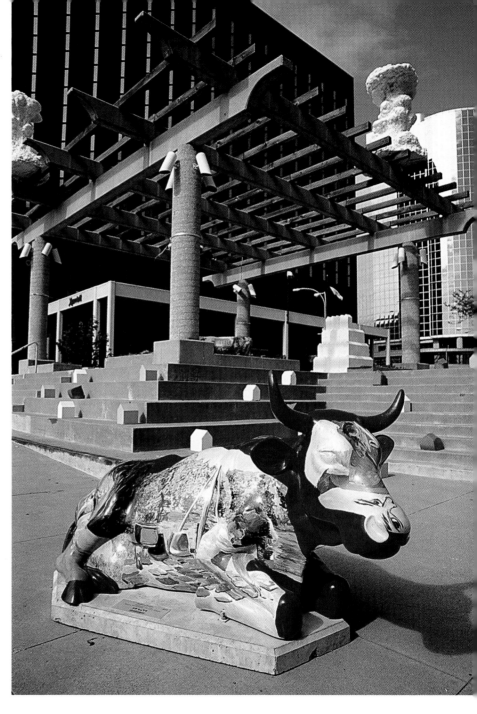

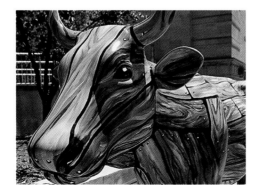

West Bottoms Bossy
Artist: Carol McCall
Patron: American Royal Association

SummerStudio
Artist: Studio 150
Patron: Donated by UtiliCorp United

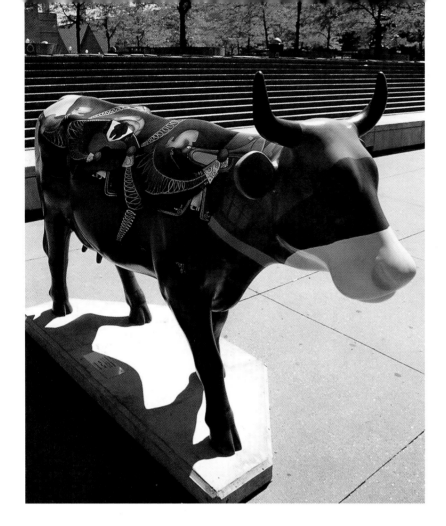

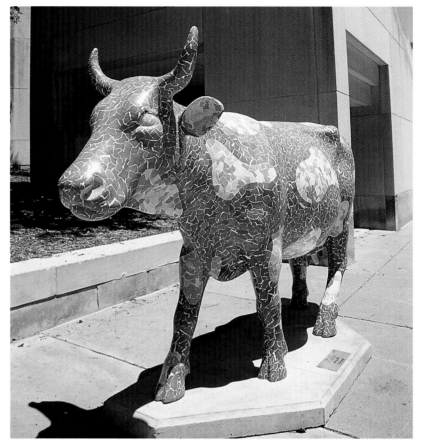

Southwest Bullevard
Artist: Jeff DeRousse
Patron: KMBC-TV 9

LOCAL LORE

The fountains at City Hall were shut off during World War II as a conservation effort. It saved Kansas City $1.50 per day in electricity charges.

Paper Cow
Artist: Justin Bell
Patron: Business Radio KPHN 1190

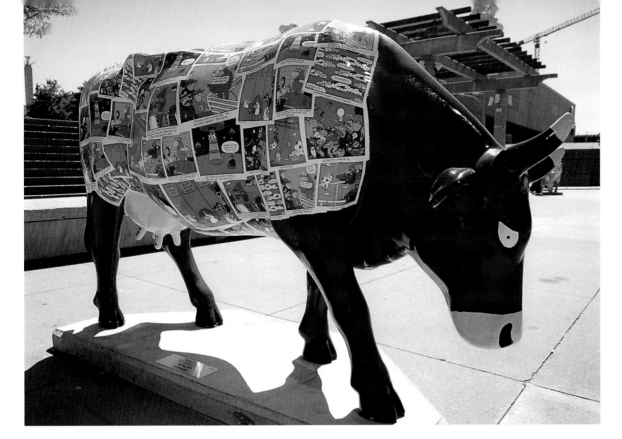

Cowtown Cow
Artist: Charlie Podrebarac
Patron: The *Kansas City Star*

Western Cow Scape
Artist: Marie Mason
Patron: Friends of the Kemper
Museum of Contemporary Art

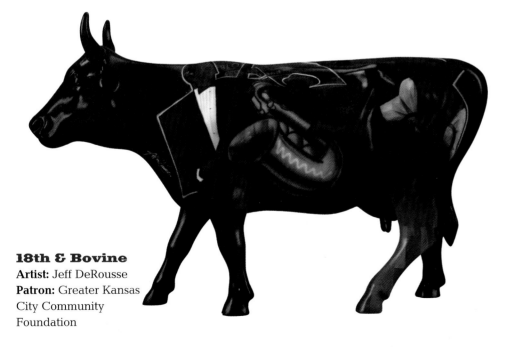

18th & Bovine
Artist: Jeff DeRousse
Patron: Greater Kansas
City Community
Foundation

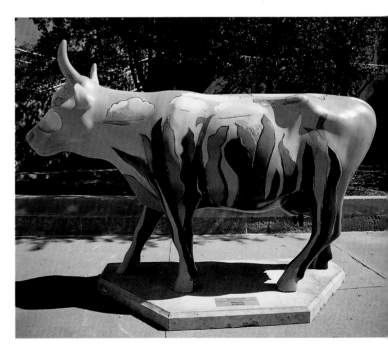

Northland Fountain Park and the area around it have been booming since the arrival of Kansas City International Airport. The region, located just across the river from Downtown, comprises Missouri's Clay and Platte counties and draws residents looking for access to the Missouri River and an easy commute to jobs in Kansas City or at nearby corporate offices.

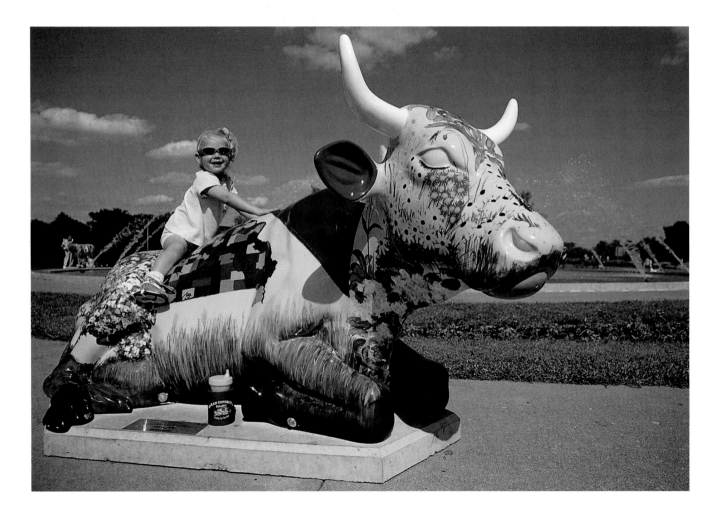

Mo Cowntys
Artist: Susan Ann Johns
Patron: UMB Financial Corporation

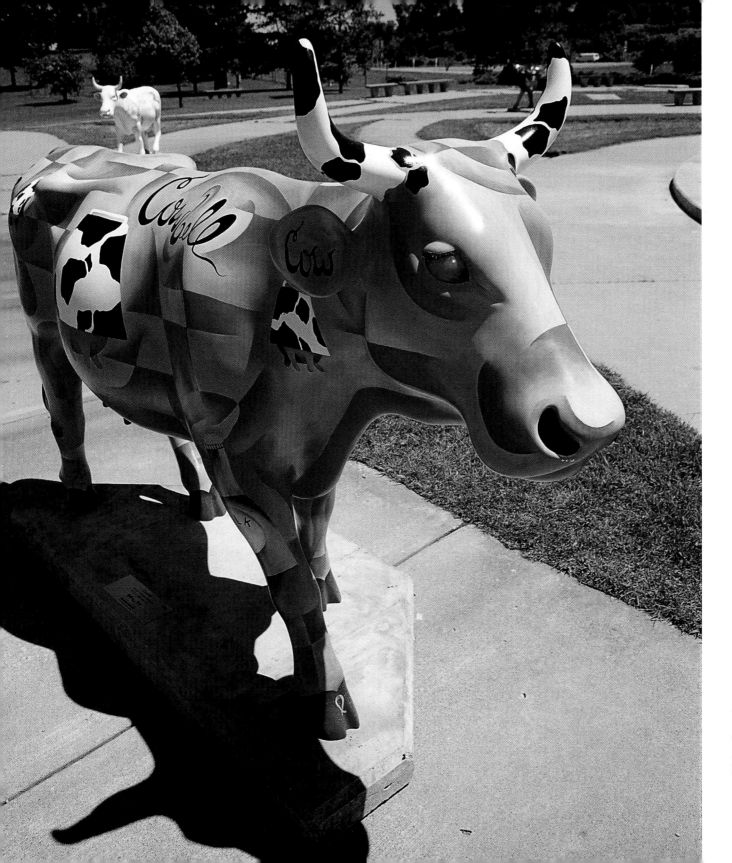

Cowbell
Artist: Melissa Dehner
Patron: DeLaval Inc.

Strawberry Ice Cream
Artist: Roger Garner
Patron: KMBC-TV 9

Herd It Through the Grapevine
Artist: Terri Sheldon-Merrill and Cheryl Spry, Second Nature Design Studio Inc.
Patron: Riverside RedX

Fashion Cow
Artist: Harmarkhis McCannon
Patron: CowParade

THE FATHER OF THE STOCKYARDS

By the time Charles F. Morse (1839–1926) arrived in Kansas City, he had led a busy life. He was a graduate of Harvard, a Union veteran of the Civil War who had fought at Gettysburg, a failed Georgia cotton planter, and a successful railway executive.

Then, in 1879, Morse accepted the job of general manager of the Kansas City Stockyards Company (KCSC). Backed by another Massachusetts man, Charles Francis Adams, Morse took the fledgling stockyard in West Bottoms and built it into the city's primary industry.

Under Morse, the KCSC employed 25,000 workers and became one of the most productive stockyards in the country—second only to Chicago's.

Moo-nay's Garden
Artist: Diane Flynn-Yi
Patron: The *Kansas City Star*

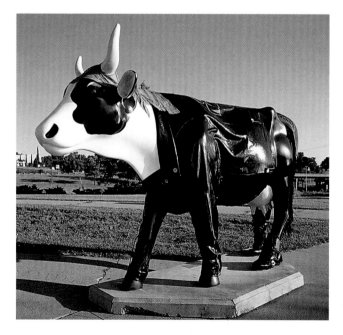

Live to Ride . . . a Cow?
Artist: Tria I. Cartner
Patron: Hearst Entertainment and Syndication

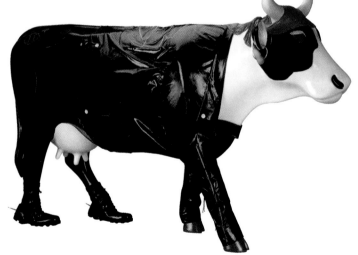

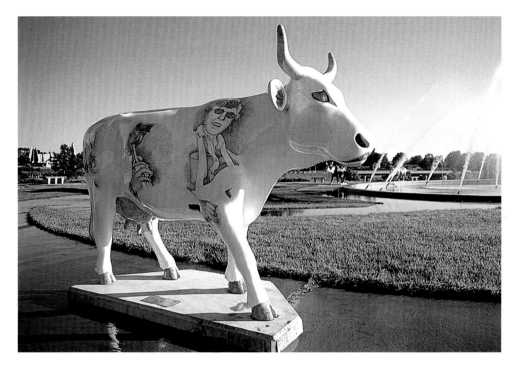

Ole Bluesy
Artist: Toni A. Watson
Patron: Kansas City Parks
and Recreation

Phases of the Moo
Artist: Harriet Kaplan
Patron: Paine Webber, Inc.

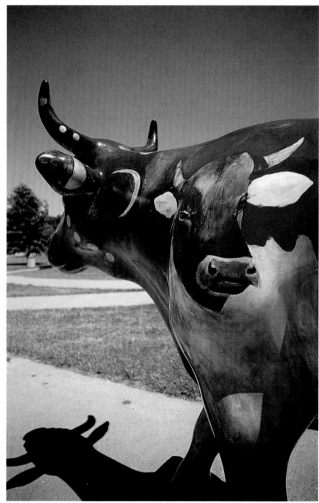

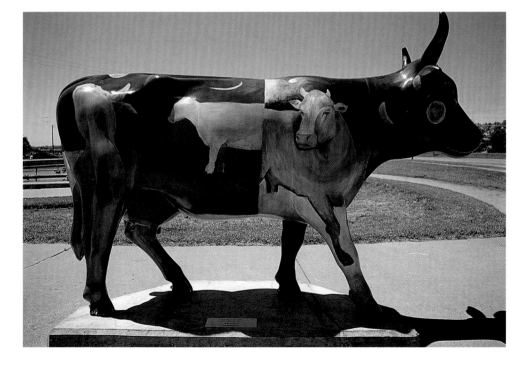

Historic 18th & Vine

Back in the 1930s and 1940s, 18th and Vine was where you went to hear the hottest sounds and the coolest rhythms. Those were the glory days of Kansas City jazz, when Count Basie, Duke Ellington, and Cab Calloway—among other legendary performers—played the Reno Club, the Harlem Nite Club, the Spinning Wheel, and the Blue Room.

Today 18th and Vine is home to the American Jazz Museum, a place that really keeps the spirit of Kansas City jazz alive. Check out the excellent exhibits, of course, but above all don't miss the Blue Room. Four nights a week this reproduction of a popular 1930s jazz joint is jumping with live performances of classic Kansas City jazz.

18th and Bovine
Artist: Julie Larson
Patron: UMB Financial Corporation

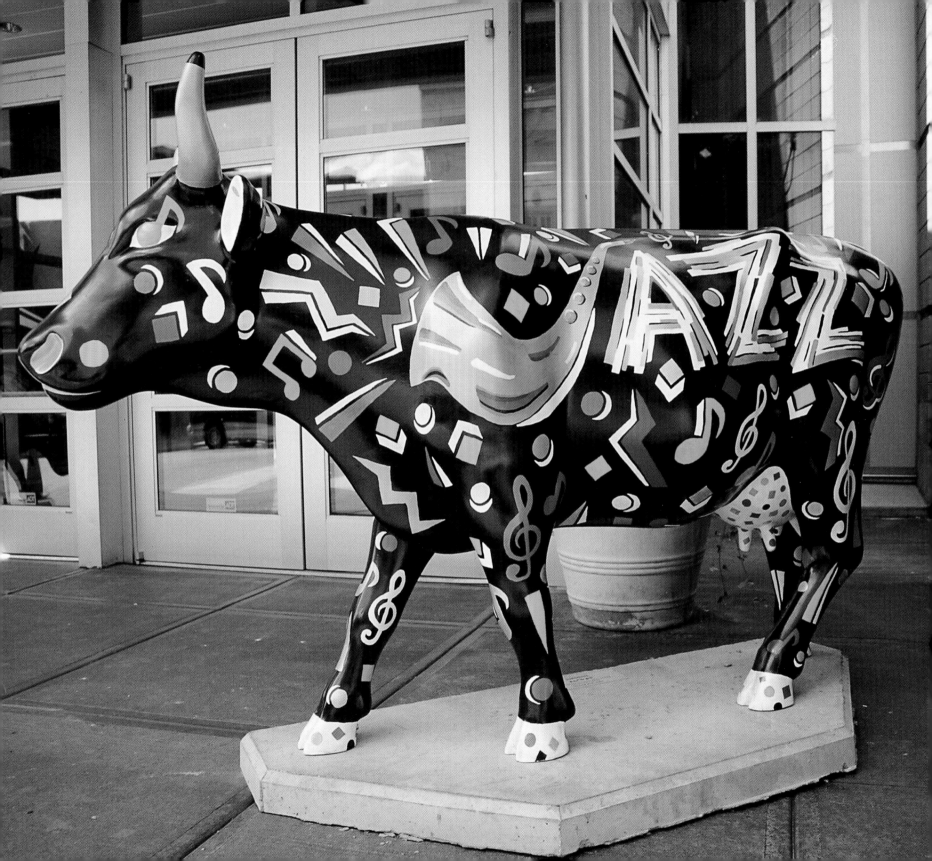

Bossy Nova
Artist: Savannah Middle School
Patron: KMBC-TV 9

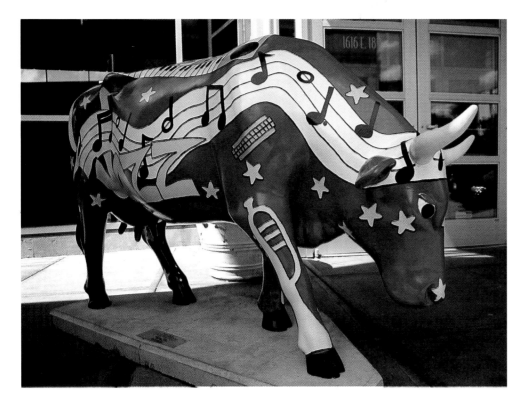

LOCAL LORE

In the 1930s, 18th and Vine was the heart of Kansas City's African-American community. Whenever the Monarchs baseball team was in town, black fans from all over the Midwest came to Kansas City. And after the game, they headed to the jazz clubs.

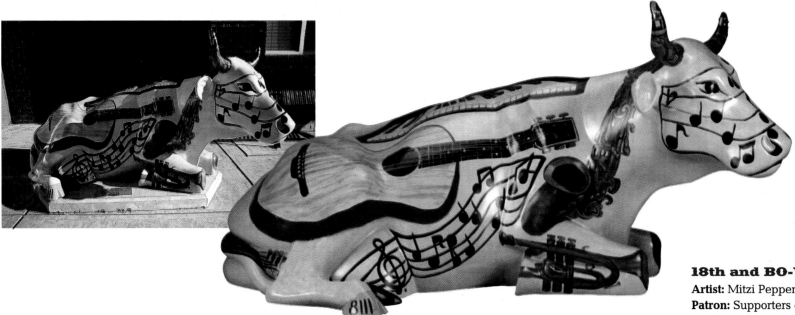

18th and BO-VINE
Artist: Mitzi Pepper Foster
Patron: Supporters of 18th and Vine

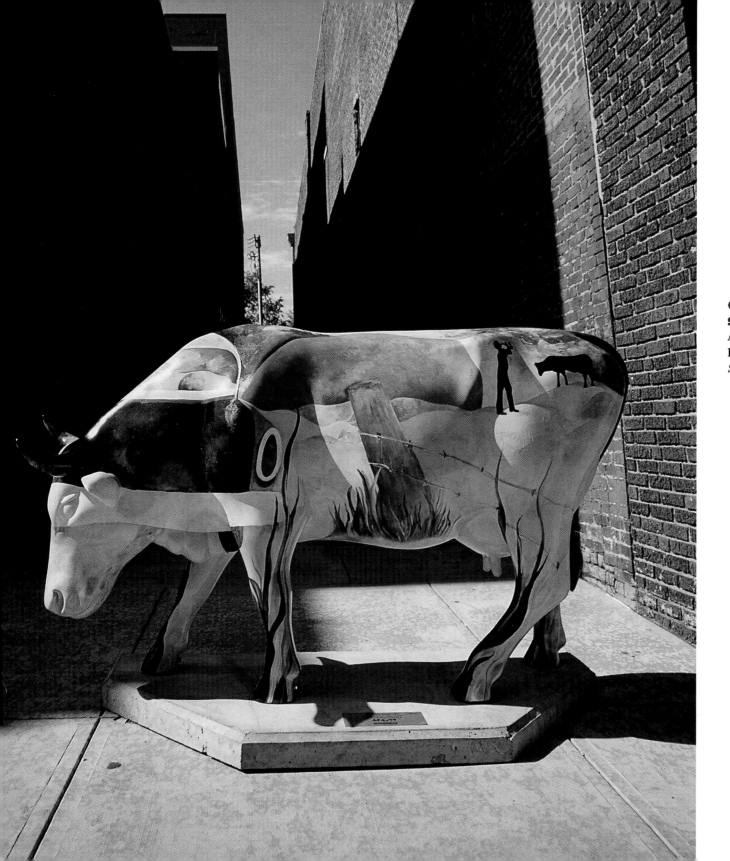

Charlie's Serenade
Artist: Keira C. Blanchard
Patron: The *Kansas City Star*

Swope Park
Starlight Theatre
Kansas City Zoo

In the late 19th century, Kansas City residents were lobbying for more public parks. One of the foremost opponents of the plan was Colonel Thomas H. Swope, a wealthy recluse who argued that setting aside vast tracts of productive land for public recreation would only raise local real estate taxes.

By 1896, however, Colonel Swope had had a change of heart. He purchased 1,334 acres of fields and woodlands about four miles from the city limits and donated the entire parcel to the city as parkland. On the day the park was dedicated, 18,000 Kansas City residents turned out for the ceremony and picnic. Colonel Swope had declined to join other dignitaries on the podium. Instead, he stood in the audience, unrecognized by the vast crowd, listening to two hours' worth of speeches in praise of his generosity.

CowZilla
Artist: Team Jünk
Patron: Kansas City Zoo

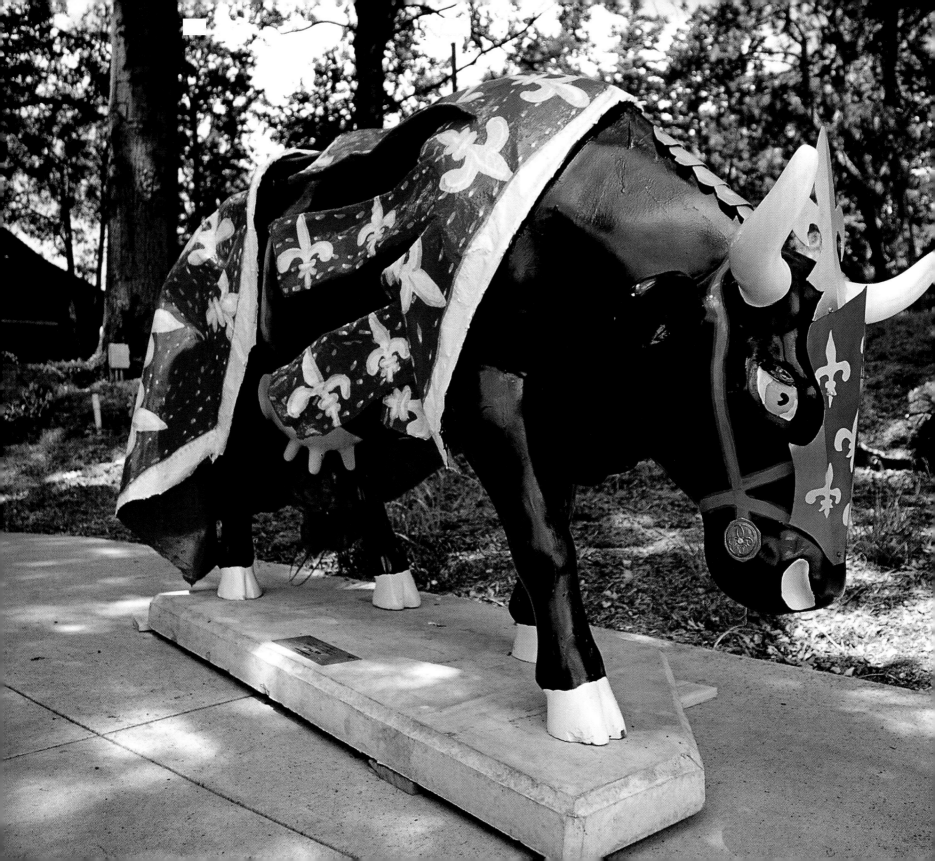

Mother Frog
Artist: Herman A. Scharhag
Patron: Friends of the Zoo

Environmental Cow
Artist: Patricia Roney
Patron: Kansas City Parks and Recreation

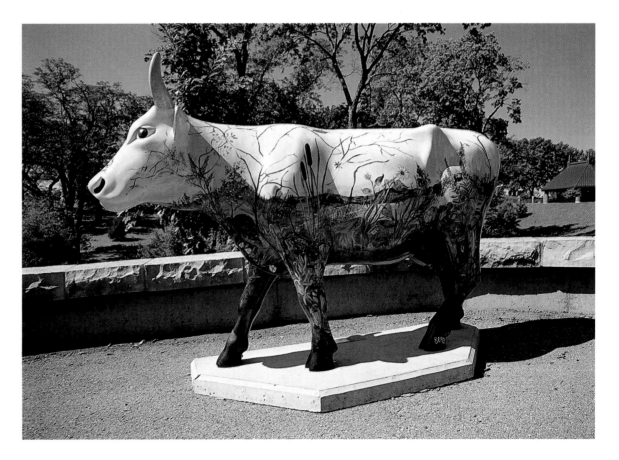

Cow-melot
Artist: Amy J. Carlson
Patron: Starlight Theatre

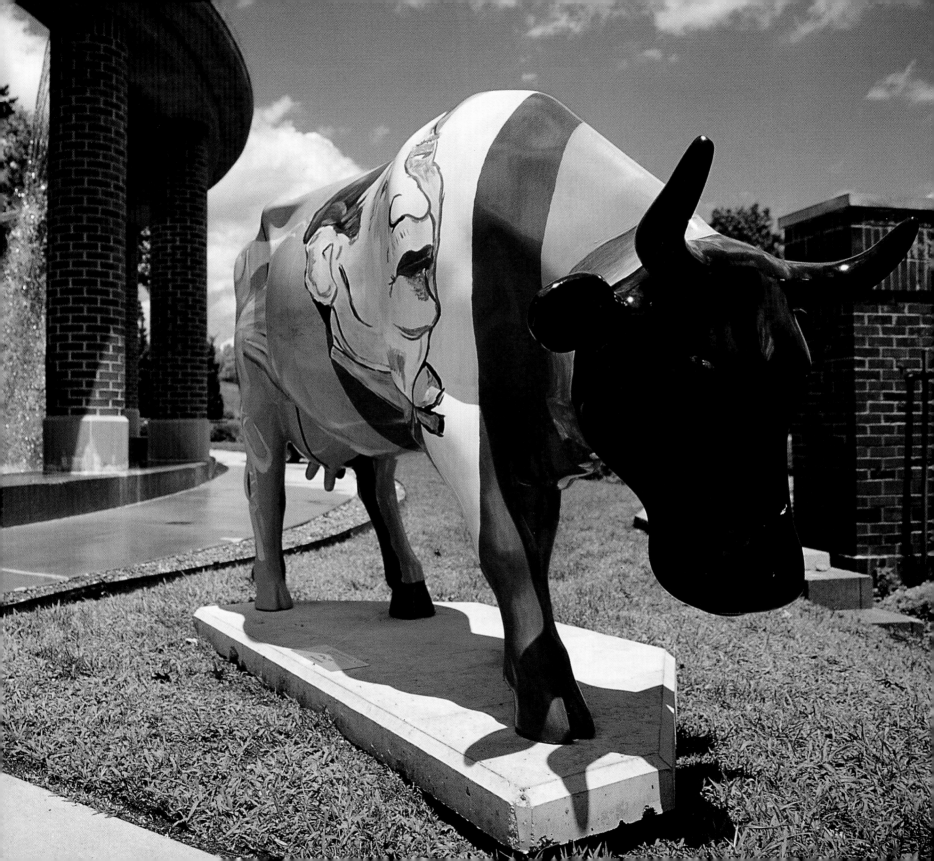

At the Moolin Rouge
Artist: Jon Fulton Adams
Patron: Starlight Theatre

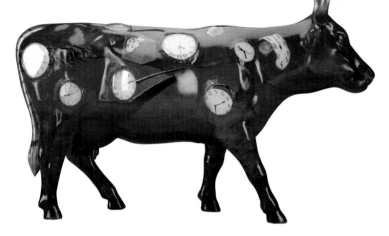

A Cow in Time Saves 9
Artist: Magical Mysticow Tour:—An HNTB Committee
Patron: HNTB Corporation

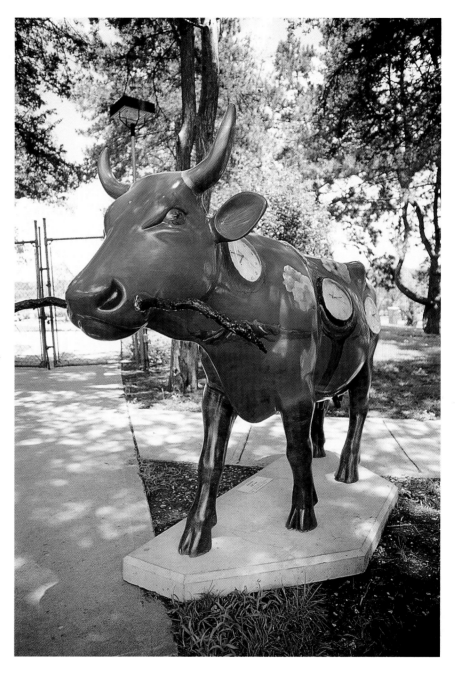

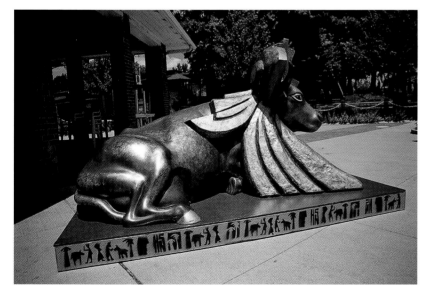

Egyptian Princess
Artist: Herman A. Scharhag
Patron: Starlight Theatre

∧ ≻

Cownt Basie
Artist: Gary Mallen
Patron: Starlight Theatre

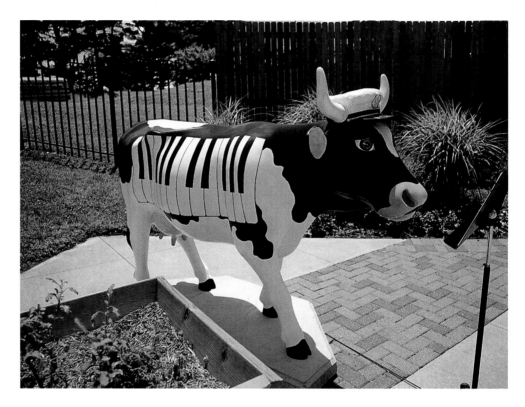

≻

Yellow Brick Roadie
Artist: Marcella G. Smith
Patron: Starlight Theatre

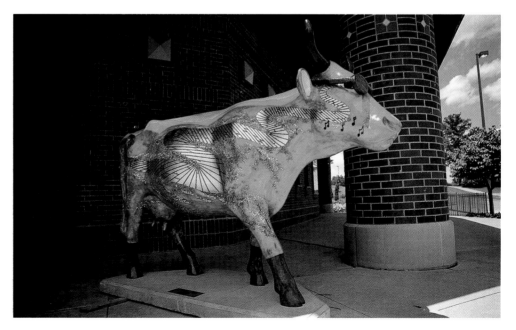

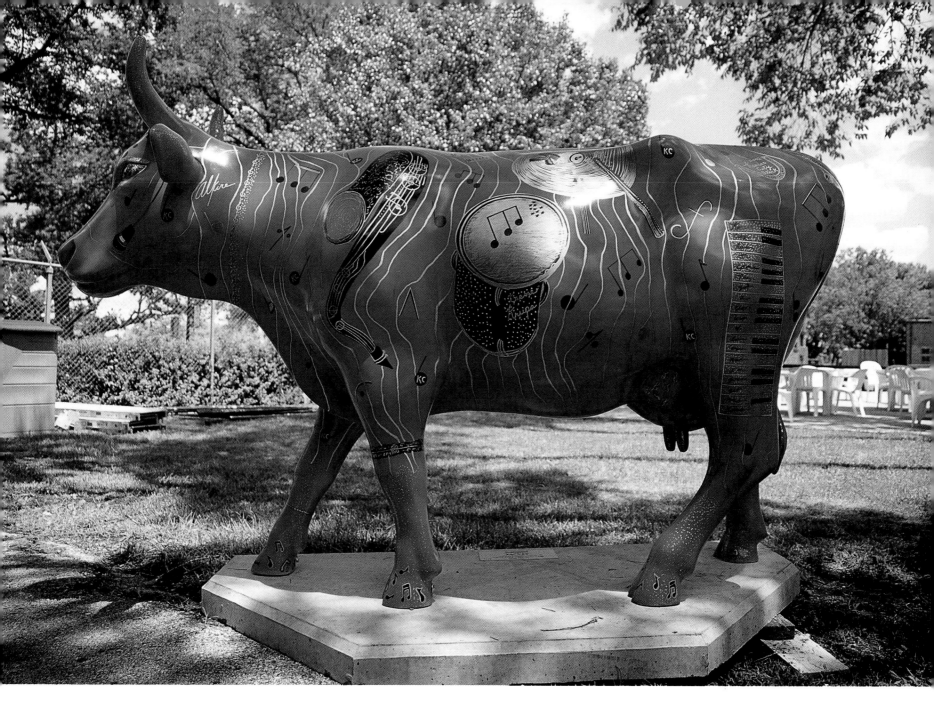

Jazzily Blue
Artist: Cindy Alkire,
Alkire Studio
Patron: Starlight Theatre

Zoo Cow
Artist: A. J. Hoyt
Patron: Friends of the Zoo

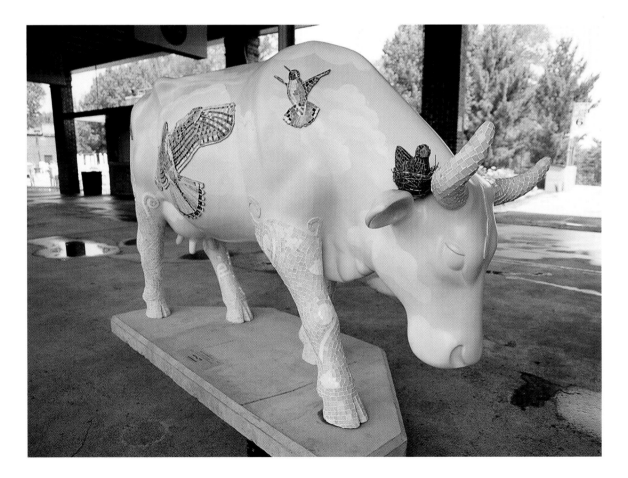

My Feathered Lady
Artist: Caryn S. Brown
Patron: Kansas City Parks and Recreation

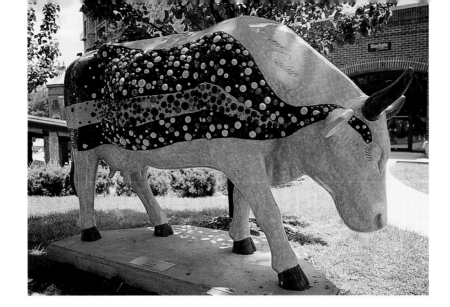

**Technicolor
Dream Cow**
Artist: Marcella G. Smith
Patron: KMBC-TV 9

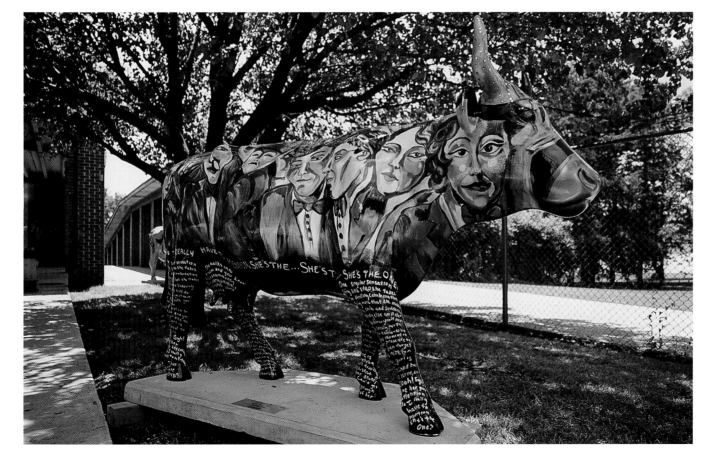

A "Cowus Line"
Artist: Nina Scalise
Patron: KMBC-TV 9

117

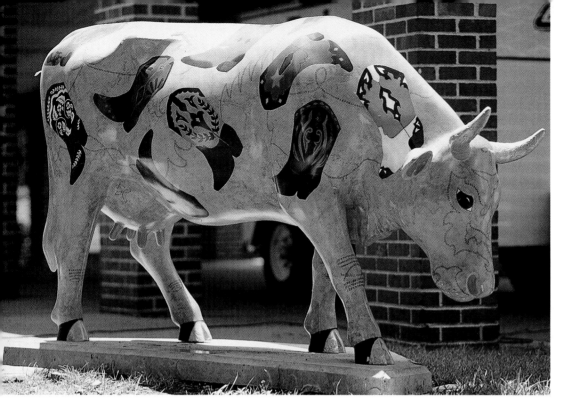

**Cowboots
(On the Hoof)**
Artist: K. P. Mills
Patron: American Royal
Association

**Boo Cow AKA
Casper Cow**
Artist: Teri Siragusa Rattenne
Patron: Supporters of
Children's Mercy Hospital

Out of Moo-souri
Artist: Jean Singer
Patron: Kansas City Zoo

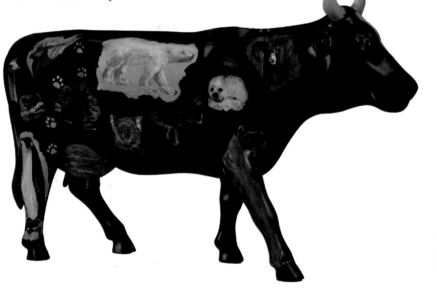

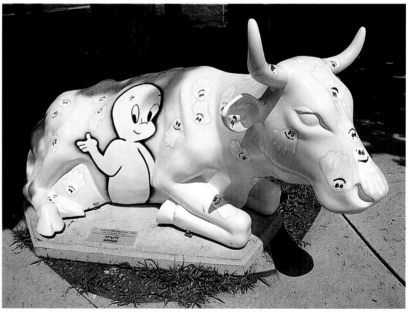

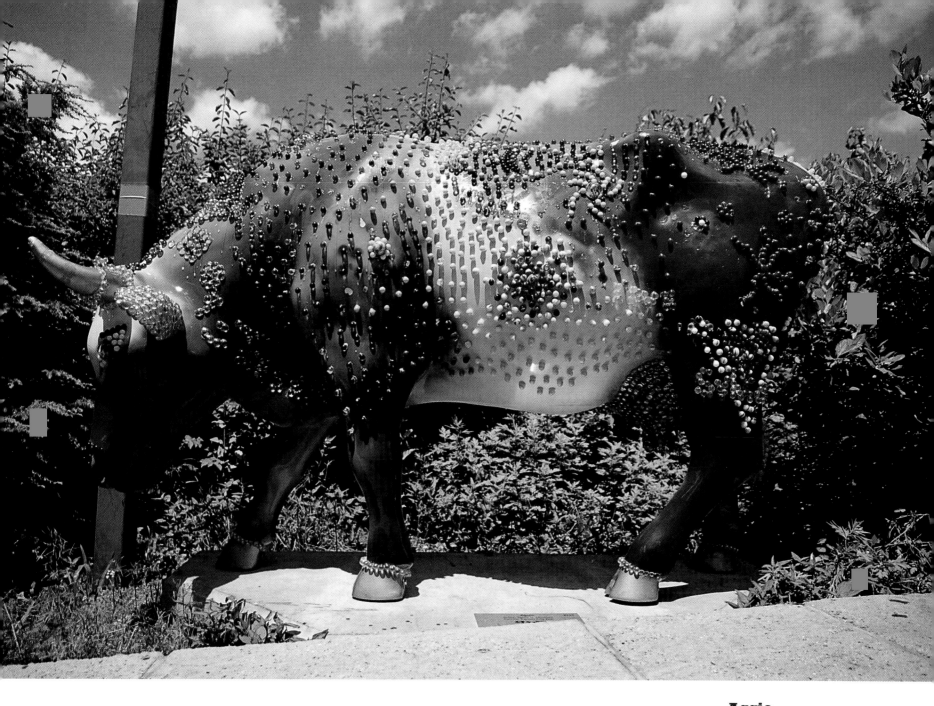

Aggie
Artist: Sylvia D. Mooney
Patron: Kansas City Zoo

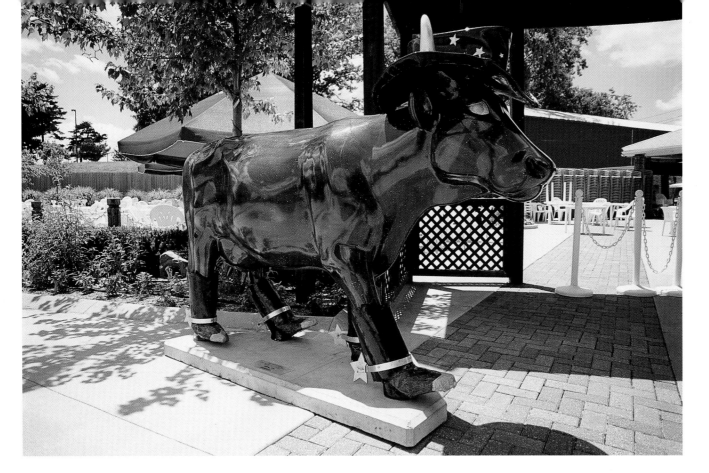

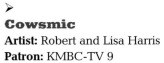

Cowsmic
Artist: Robert and Lisa Harris
Patron: KMBC-TV 9

Midnight Cowboy
Artist: Terri Oglesby and
Heather McDonald
Patron: The *Kansas City Star*

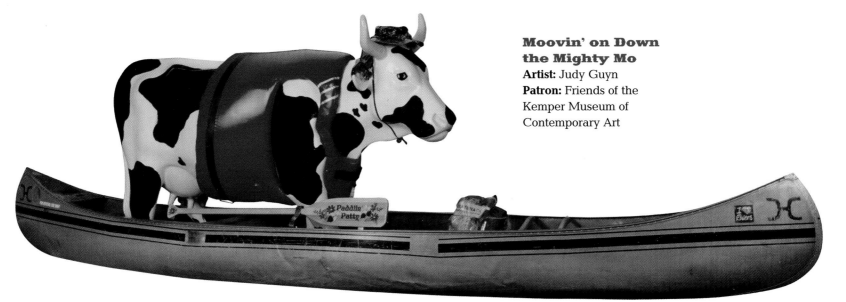

**Moovin' on Down
the Mighty Mo**
Artist: Judy Guyn
Patron: Friends of the
Kemper Museum of
Contemporary Art

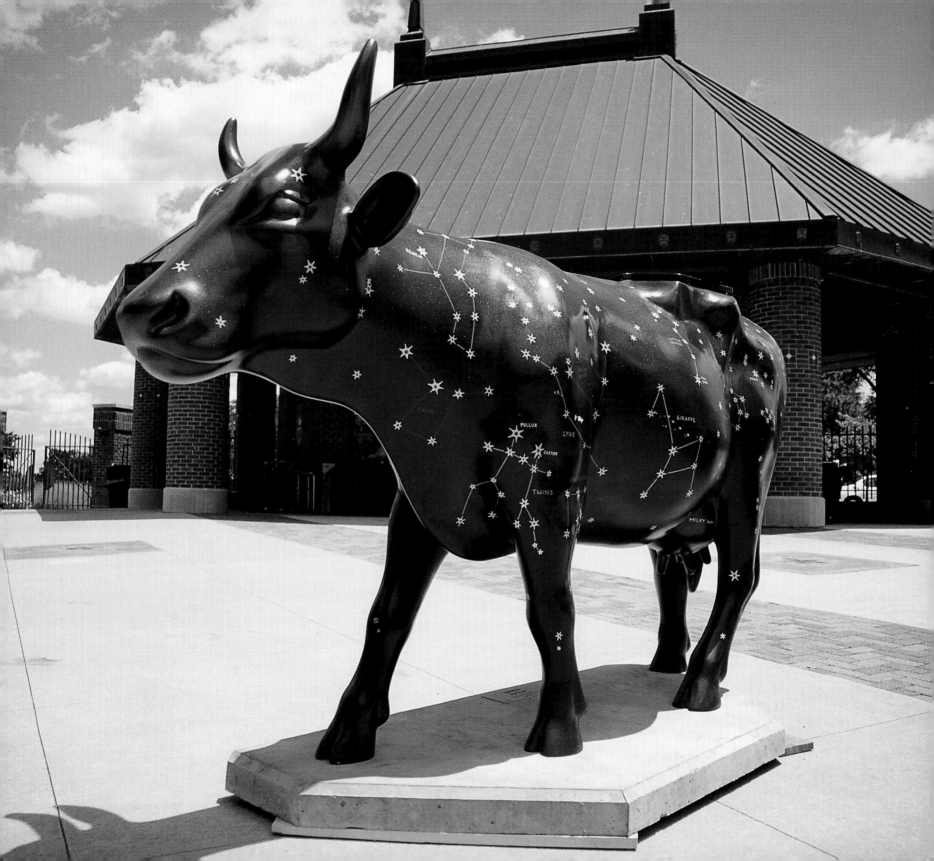

Overland Park

In 1998 ground was broken for the Corporate Woods office complex in Overland Park. By early November 2000, all office space in all four buildings was leased. The business campus is a sign of the ongoing shift—which started 40 years ago—of businesses from downtown Kansas City to the suburbs.

With nearly 500,000 square feet of office space, access to the Earth City Expressway, and an easy commute from such neighborhoods as Hallbrook Farms, Corporate Woods has become one of the most desirable commercial properties in the Kansas City area.

Ethel
Artist: Lori Raye Erickson
Patron: King Features

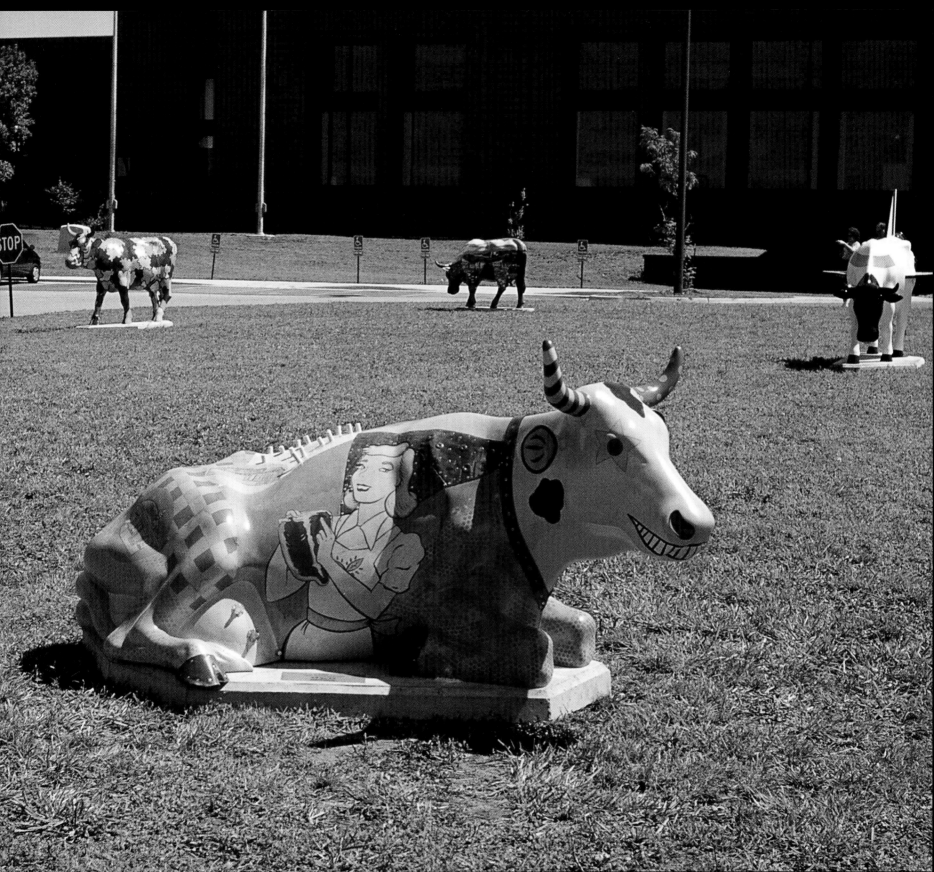

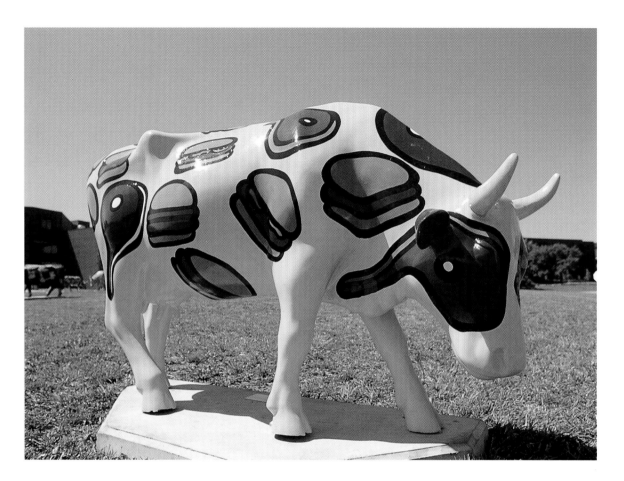

Steer Clear

Artist: Marco
Patron: Segal Fine Art

Kansas Cow: Grazing

Artist: Vicki Evans Scanlon
Patron: Accenture

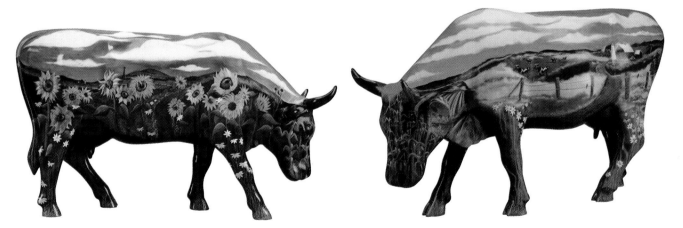

124

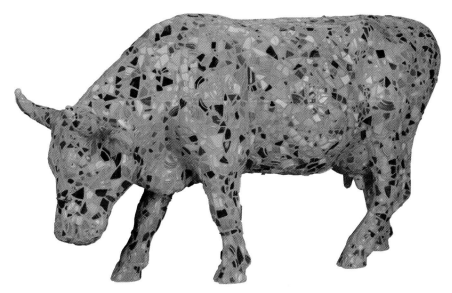

Moozaic
Artist: Joe Boeckholt
Patron: KMBC-TV 9

Space Shuttle Cow
Artist: Dave Fisher
Patron: The *Kansas City Star*

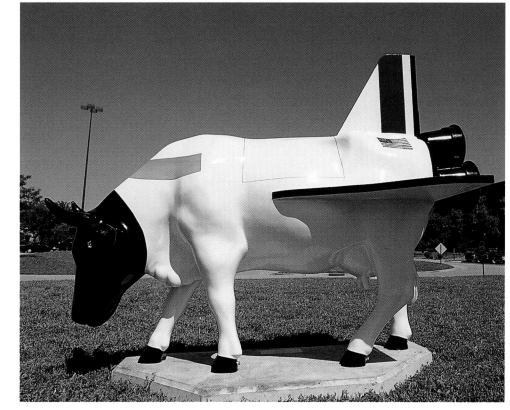

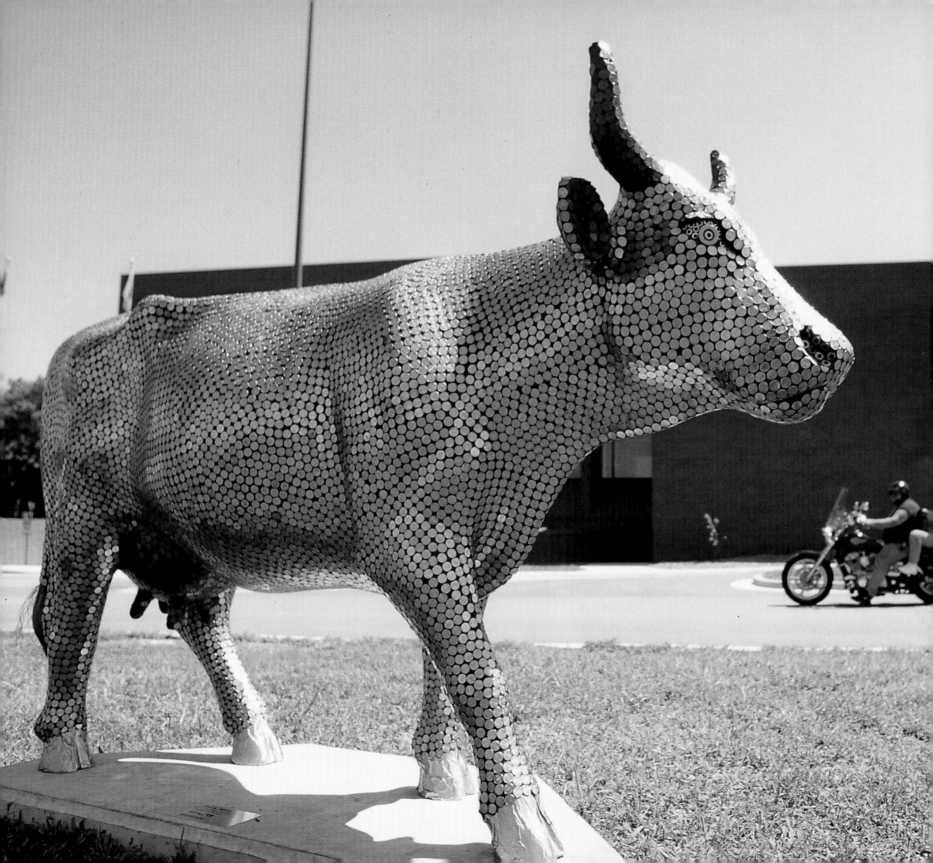

Moo-la, Moo-la
Artist: Lara René Frashier
Patron: Accenture

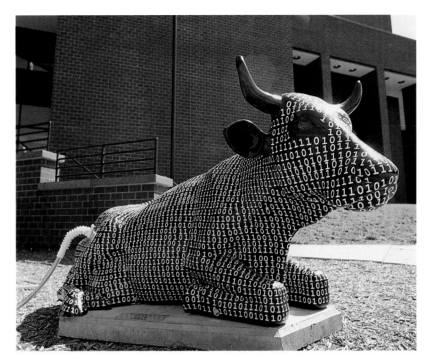

Everything's Up to Date in Kansas City
Artist: Bill Todd
Patron: Accenture

Grounded in Native Plants
Artist: K-State Extension Master Gardeners
Patron: Corporate Woods

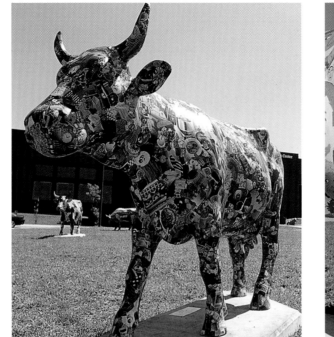

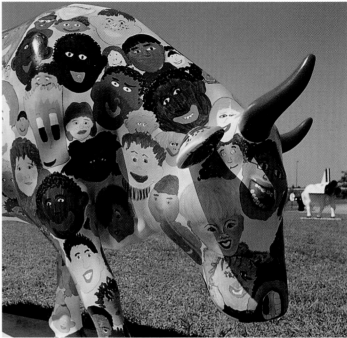

Cowtalog
Artist: Sherry L. Jackson
Patron: Schaefer
Associates, Inc., Kansas
City Gift Mart

Udder Delight
Artist: NOVA Center
Patron: Accenture

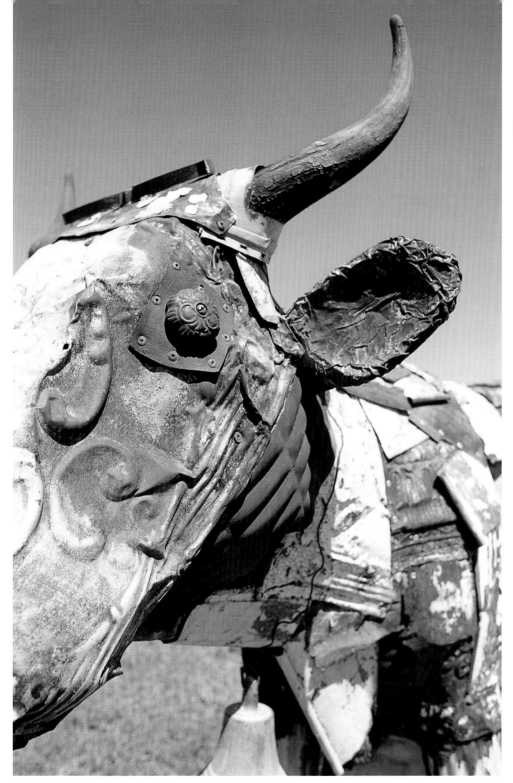

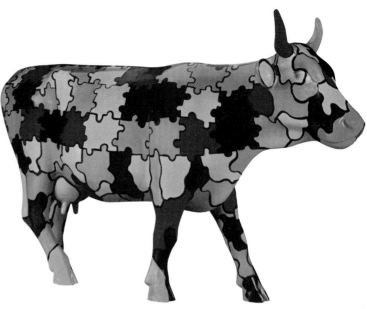

Putting It All Together
Artists: Sarah Butler and Darryl Woods
Patron: Accenture

Cowtaloupe
Artist: Kingswood-Oxford School
Patron: CowParade

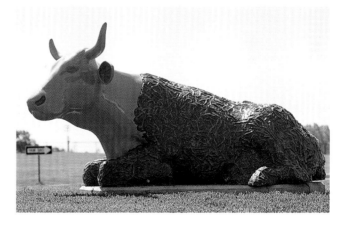

Rusty Anna
Artists: Dana Swedo, Eddie Bernal, Angela Grisales
Patron: Friends of the Kemper Museum of Contemporary Art

Kansas City, Kansas, Courthouse

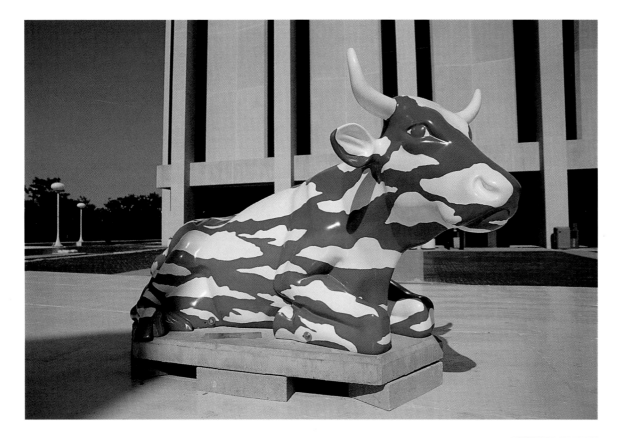

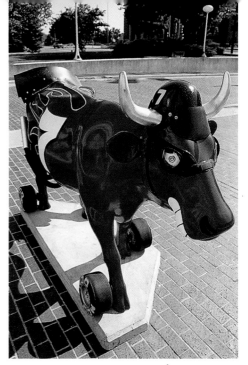

⋀ ⋗

Nascow Stockyard Race Cow
Artist: Charlie Podrebarac
Patron: The *Kansas City Star*

Moo Skies
Artist: Darleen Welty
Patron: KMBC-TV 9

Eighteenth and Bovine
Artist: Sharon Reeber
Patron: CowParade

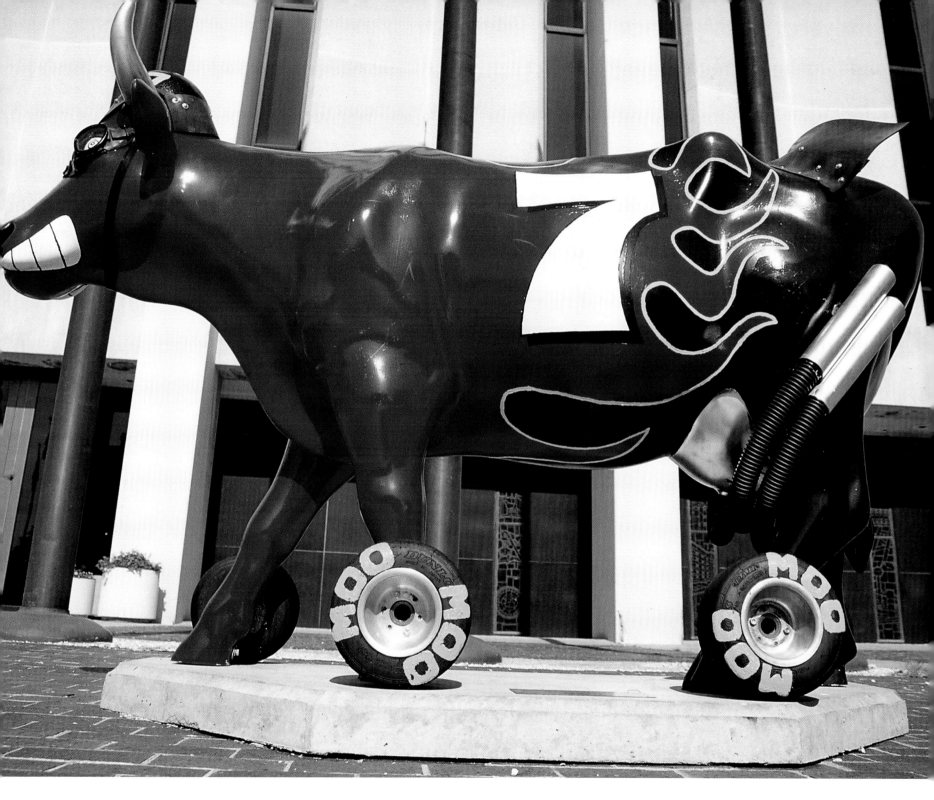

131

Prairie Village

fter real estate developer J. C. Nichols completed his renowned Country Club Plaza shopping complex in 1922, he turned his attention back to his home district, Johnson County, Kansas. Nichols imagined a beautiful planned community set amid the rolling hills and meadows outside Kansas City. Work on Prairie Village began in 1941. Nichols's timing was perfect: Prairie Village was Kansas City's answer to the tremendous housing shortage that followed World War II.

In 1949, Nichols's visionary approach won nationwide acclaim when the National Association of Home Builders named Prairie Village the best planned community in America.

Teal
Artist: Michael Graves
Patron: Target Stores

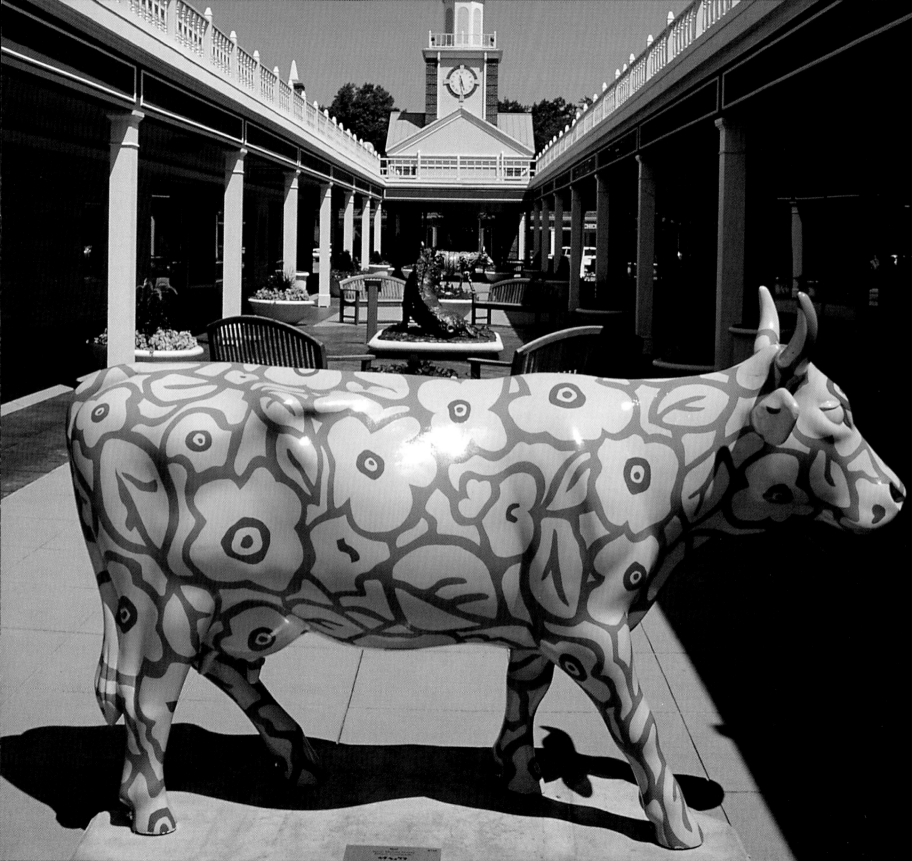

Crayon
Artist: Candida Bayer
Patron: The *Kansas City Star*

Tattooed Bovine
Artist: Georges Le Chevallier
Patron: Prairie Village Shops

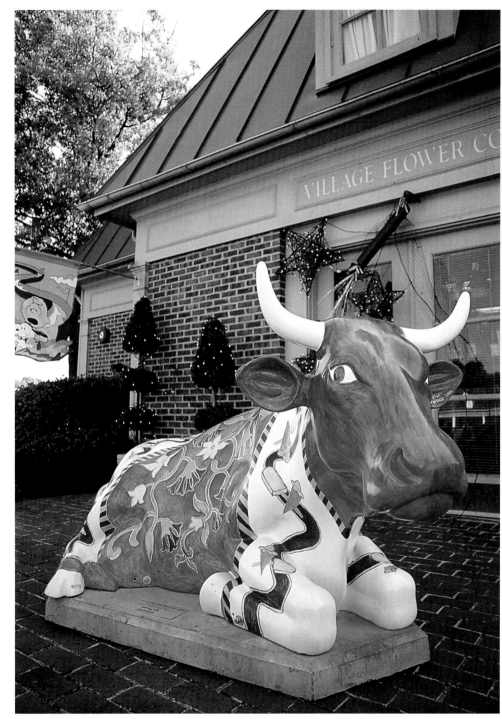

2001 A Space Cowboy Oddity
Artist: Roger Garner
"RAD"
Patron: Prairie Village Shops

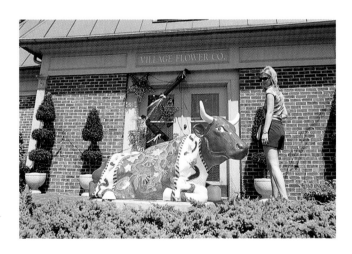

Flossie, the Floral Blue Cow
Artist: Janice C. Atkins
Patron: Prairie Village Shops

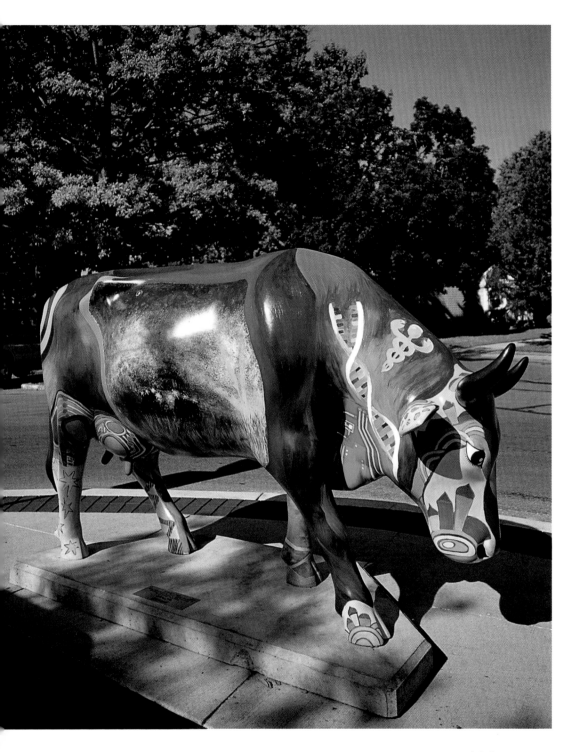

A Moo in June

Artist: Professor Winston Branch, Megan Christensen, Jack Hayes, Micah Tenner, Yui Udo, Dana Rose
Patron: Prairie Village Shops

Psycowdelicowwow
Artist: Cathy Kenton
Patron: Prairie Village Shops

Classicow Greek Goddess
Artist: Susi Lulaki
Patron: Prairie Village Shops

Shawnee Mission Park

In the 1820s and 1830s, the Shawnee Indians were moved from the Eastern United States to a large parcel of land just west of the Missouri River. Needing a school for their children, they recruited Methodist minister Thomas Johnson to establish a mission. Shawnee Mission opened in Wyandotte County, Kansas, in 1830, and nine years later moved to its present location in the town of Shawnee. The school quickly grew from one building to a complex that at its peak covered 2,000 acres and boasted 16 buildings.

When the Kansas Territory was established in 1854, the mission was used as the seat of the new government. Today it is a historical center run by the Kansas State Historical Society.

Moo Shoe
Artist: Iris Rosenberg
Patron: CowParade

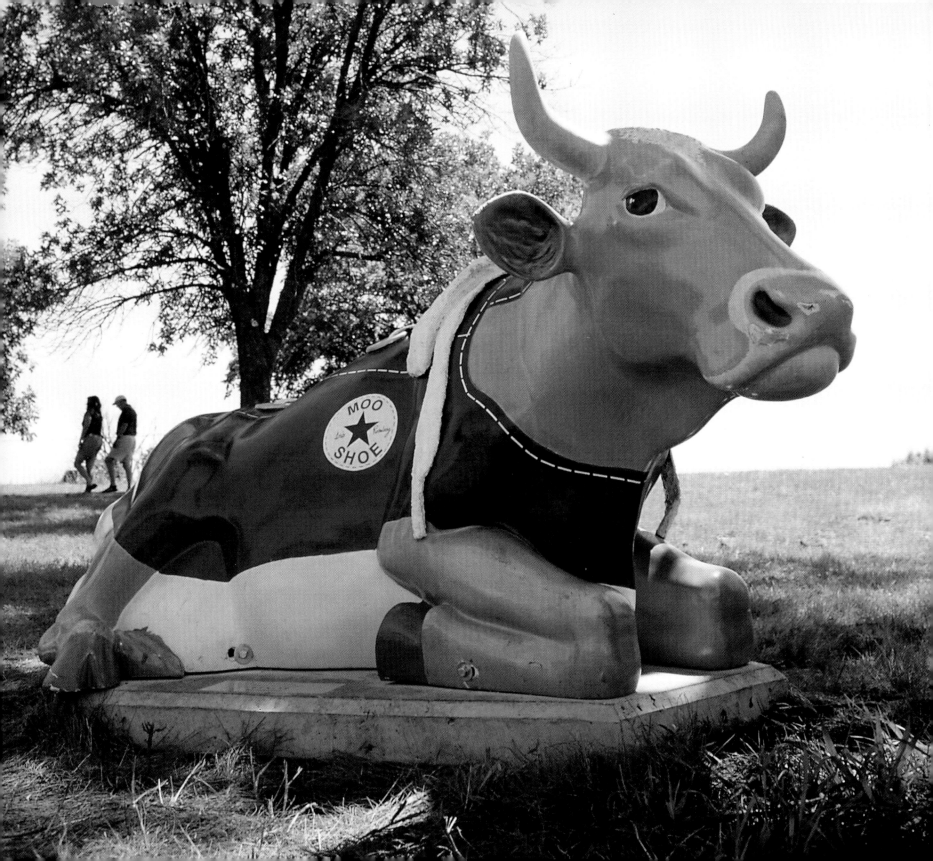

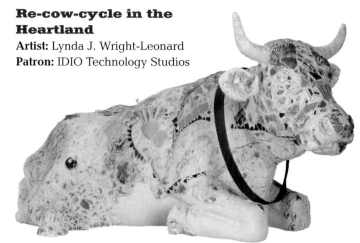

Re-cow-cycle in the Heartland
Artist: Lynda J. Wright-Leonard
Patron: IDIO Technology Studios

K.C. Moospapers (Black & White & Read All Over)
Artist: Reida Morrison York
Patron: The *Kansas City Star*

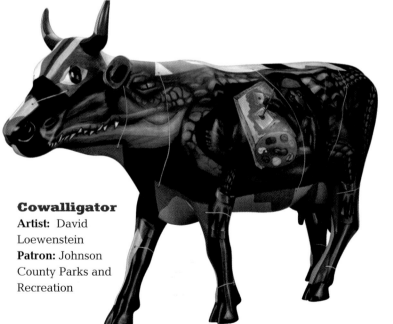

Cowalligator
Artist: David Loewenstein
Patron: Johnson County Parks and Recreation

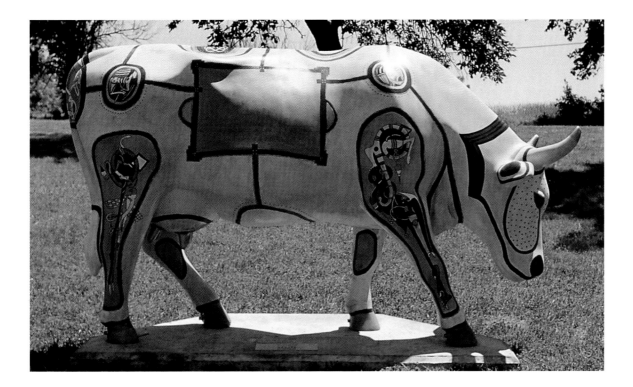

The Cow of Kells
Artist: Liam Daly
Patron: Belger Cartage
Service Inc.

Koiow
Artist: Kathy Hinkle
Patron: Kansas City Zoo

**An Udderly
MOO-jestic View**
Artist: Arlene Haner
Patron: KMBC-TV 9

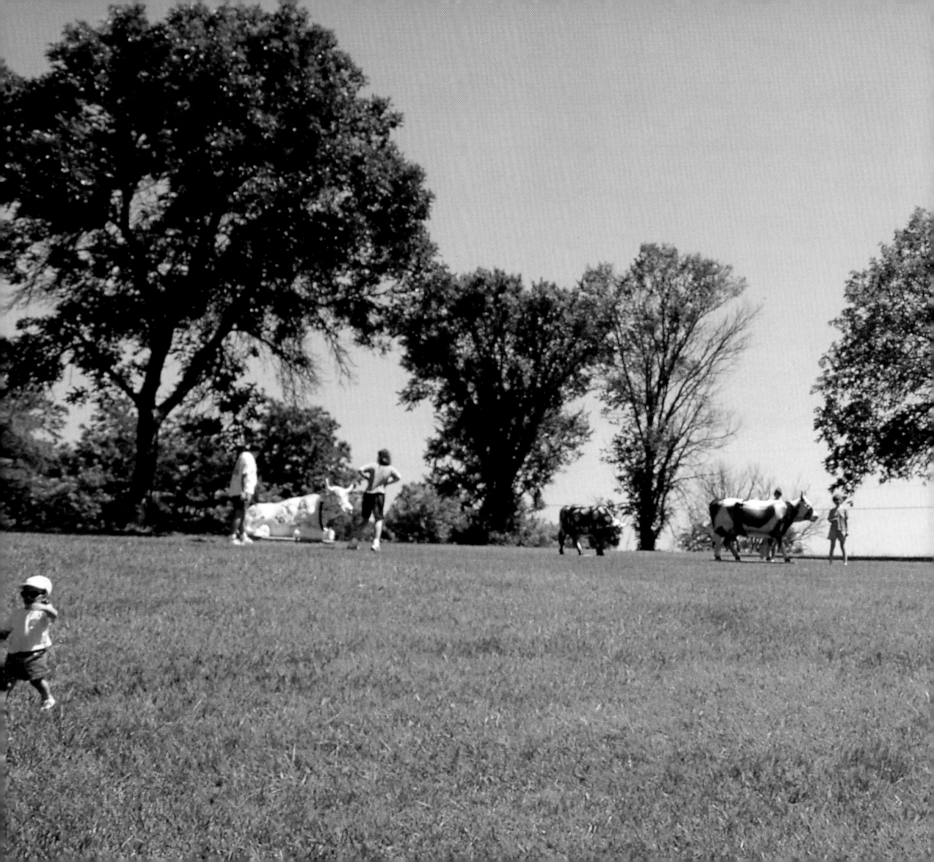

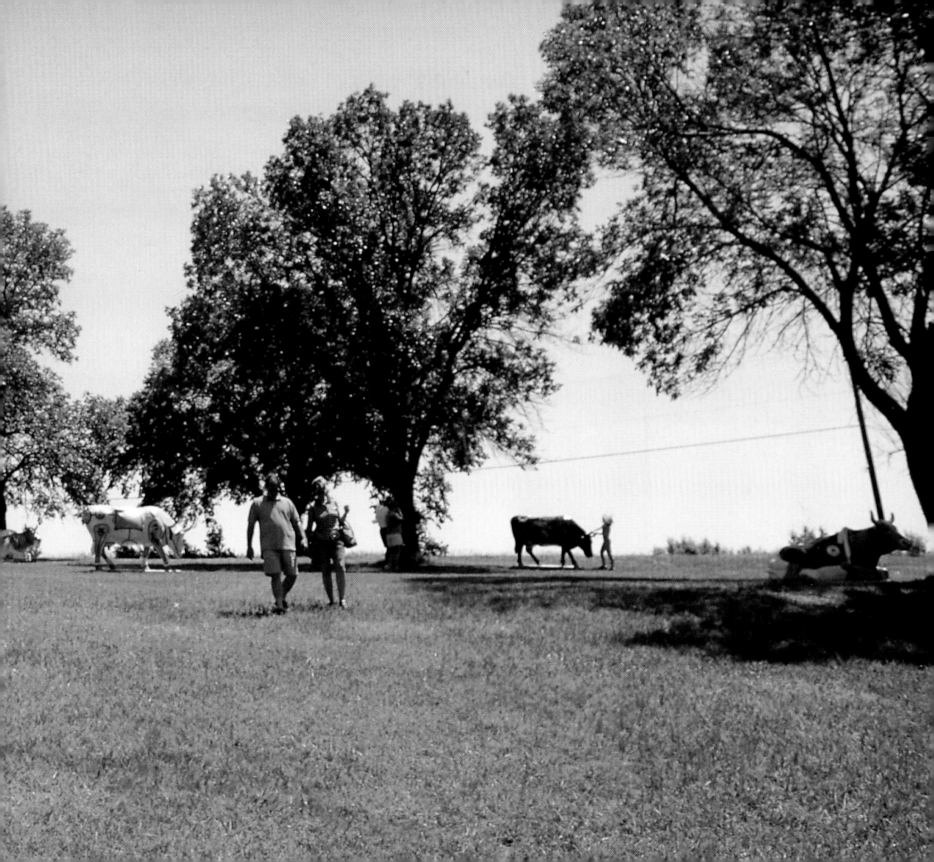

ABOUT THE BENEFICIARIES OF COWPARADE KANSAS CITY

The cows of CowParade Kansas City will be auctioned off after they have enjoyed their run of the Kansas City streets. The proceeds of the auction will benefit children's education programs of the American Royal Association, the Kansas City Zoological Park, and the Kemper Museum of Contemporary Art.

The American Royal Association is dedicated to promoting awareness of metropolitan Kansas City's strong agricultural heritage. Its year-round programs include Rodeo Education And Children (REACh), which, through rodeo events, teaches students about honesty, rugged individualism, and drug and gang prevention; Kids Ag Learning Fest (KALF), an agricultural summer program that stresses interaction with animals; World of Agriculture, in which kids make butter, grind grain, and create crafts to learn about Kansas and Missouri commodities and the effect of agriculture on their daily lives; the Metropolitan Scholarship Program, for high-school students from the six-county metropolitan area; the Student Ambassador program, which provides scholarships and internships to college students; and the American Royal Museum, where children learn about Kansas City's heritage and the museum itself.

The Kansas City Zoological Park has grown from one small building to more than 200 acres of land in the last 80 years. Not only is it a research and education center for environmental and wildlife conservation; it is also an integral part of the community, enabling visitors to learn firsthand about nature and to work toward a better environment for animals and humans.

The Kansas City Zoo's Education Program, which offers nearly 100 different programs, reaches 300,000 children and adults year-round. Zoo School makes summer a time for learning and fun. Through tours, animal-keeper talks, activities, and art projects, children explore the world of wildlife at the zoo. During Wild Safari Tours, experienced safari guides take visitors to the far reaches of the world without leaving the zoo—to the Kopje region of Kenya, to Tanzania, to Uganda's Kibale National Forest, or to the Okavango Elephant Sanctuary. For the night owl, the zoo offers nocturnal safaris—a unique African overnight adventure during which campers can fall asleep to the sounds of lions roaring in the distance.

For those who cannot come to the zoo, the Zoomobile goes out to them, bringing slides, biofacts, and live animals that can be touched. The education program for teachers offers courses and workshops that deliver in-depth information and teaching tips on conservation, wildlife, and ecology.

The Kemper Museum of Contemporary Art is a growing force in contemporary art. Each year, the museum presents 10 to 12 special exhibitions of its expanding permanent collection and of works by emerging, mid-career, and established artists. Its exhibitions and programs are offered free for all to enjoy.

Proceeds from CowParade Kansas City will benefit more than 50 different educational programs presented by the museum and designed for children, families, students, and adults. Programs like family day, children's hands-on workshops, artist residencies, performing-arts events and concerts, gallery talks, docent-led tours, and film series will continue to provide a variety of opportunities for visitors to explore contemporary art. More than 40,000 children visit the museum and participate in its programs annually.

A major focus for students includes the Kemper Museum's Artist-in-Residence Program, in which student groups interact with artists exhibiting at the museum. Artists-in-residence spend several days at the museum discussing their work, introducing new techniques, and leading art-making activities with students from area schools. This allows students to more fully understand contemporary art, its media, and its messages, and it helps them make connections between what they see in the museum and their own lives. The museum hosts five different artists-in-residence each year.

INDEX OF SPONSORS

Buttons and Bovine
Artist: Teresia Harding
Patron: University of Health Sciences

Moonarch
Artist: Sam M. Cangelosi
Patron: News Radio 980 KMBZ

Total Cownnection
Artist: Daniel Sulewsky and Myron Griffing
Patron: Sprint PCS

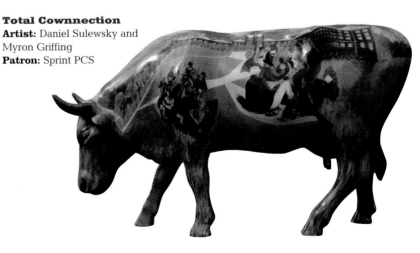

INDEX OF ARTISTS

Moo...n River Over Riverside
Artist: Park Hill South High School
Patron: City of Riverside, Missouri

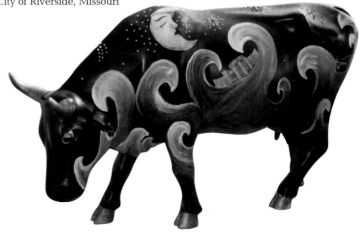